Postcard History Series

Westerly

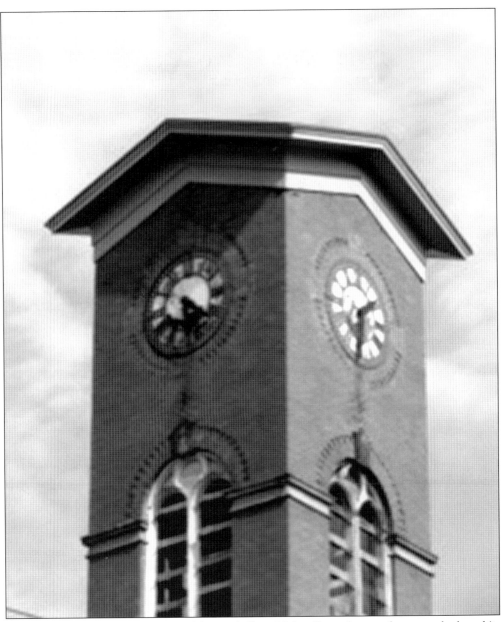

The clock tower that sits upon the old town hall on Union Street houses the town clock and its wonderful-sounding bell that was hung on June 20, 1882. At the time of installation, the clock was the area's official timepiece by which all other clocks were set.

On the front cover: Please see page 10. (Provided by the author.)

On the back cover: Please see page 86. (Provided by the author.)

Postcard History Series

Westerly

Joseph P. Soares

Copyright © 2006 by Joseph P. Soares
ISBN 0-7385-4950-9

Published by Arcadia Publishing
Charleston SC, Chicago IL, Portsmouth NH, San Francisco CA

Printed in the United States of America

Library of Congress Catalog Card Number: 2006933442

For all general information contact Arcadia Publishing at:
Telephone 843-853-2070
Fax 843-853-0044
E-mail sales@arcadiapublishing.com
For customer service and orders:
Toll-Free 1-888-313-2665

Visit us on the Internet at www.arcadiapublishing.com

*For Joseph and Elizabeth Soares, my parents.
As the years passed by, the fond memories remain,
crisp and clear, undiminished by time.*

Contents

1. Around Town 9

2. Along the Shore 27

3. Churches and Schools 59

4. Pawcatuck River 69

5. Transportation and Trade 79

6. Wilcox Park 95

7. Times to Remember 109

Acknowledgments

We must acknowledge Westerly's proud and historic past, a worthy tribute to those hardy pioneers and their descendents who settled here. These first settlers were a proud people who strived to build a town of quality, one of which could provide future generations with an admirable place to live. I, like many others who live in a town that borders Westerly, possess fond memories of Westerly, with its bustling downtown shops, tranquil park, and scenic shore. For the towns of Hopkinton, Richmond, and Charlestown, all of which derived their landmass from Westerly, a kindred tie exists, one of reverence to Westerly's early history.

I would like to thank the many people who took the time to assist me in compiling the information for this book. I would like to thank the Westerly Historical Society for their assistance and the use of several postcards exhibited in this book. The Westerly Historical Society has done a wonderful job since its inception in preserving our local history, and we should all support the society in this important job. Thomas Wright, president of the Westerly Historical Society, took the time to assist me in my efforts for images and information needed. Dwight Brown, archivist for the society, helped in providing the necessary postcards requested for use in this book.

I am grateful for all the assistance provided by the University of Rhode Island and University Library. Professor David C. Maslyn, head of Special Collections, and his staff were extremely helpful in assisting me in my research. Their vast resources and professionalism were invaluable.

I would like to thank Edward Morrone for his assistance, Pat Baily for her contribution to this project, Stephen Nichols and Sandy Avery for their encouragement and support, and the Westerly Library for the use of research material. I especially want to thank my wife, Janice M. Soares, for her support and encouragement throughout this project. We should give acknowledgment and thanks to the efforts and dedication of the *Westerly Sun,* which has done an admirable job over the many years in its reportage in accurately recording for future generations Westerly history.

Where marked, images are courtesy of the following:
Westerly Historical Society (WHS)
University of Rhode Island, Special Collections (URI)
Sandy Avery (S. A.)

Introduction

The town of Westerly, situated in the southwestern corner of the state of Rhode Island, possesses a rich history, one of such that could rival any other in New England. Westerly was the first town incorporated in the King's Province on May 14, 1669, and the fifth town in the colony. It contained an area of 153.4 square miles, territory that now belongs to the four towns of Westerly, Hopkinton, Charlestown, and Richmond. It was the largest town in the colony from 1669 to 1674 except for Providence.

On June 23, 1686, the name was changed from Westerly to Haversham, but the former name was restored in 1689. Over time, land was taken from Westerly to create the towns of Charlestown, Richmond, and Hopkinton. Westerly's boundary runs along the Pawcatuck River, a waterway where some of Westerly's significant early maritime history was carried out. In early Westerly, the shipbuilding industry took hold and along the banks of the Pawcatuck, the Greenman and Sheffield Shipyards built a number of sloops, schooners, brigs, barks, full rigged ships, and many other crafts.

Many of Westerly's hardy sons built some of the finest vessels in New England. Some of these ships, such as the *Charles Phelps*, are legendary. In 1842, Charles P. Williams of Stonington, Connecticut, contracted the Greenman Shipyard, located at the lower end of Margin Street, to build a fully rigged vessel of nearly 400 tons. This ship, known as the *Charles Phelps*, was used in the whaling industry. After making a number of voyages to the Arctic for whales that greatly enriched her owners, she was sold to the United States Government where she served valiantly during the Civil War. She had been sunk at the mouth of Charleston Harbor to blockade the channel. After the capture of Charleston, she was raised and used to transport coal. She was then sold to New Bedford parties where she was refitted and was once again used in the old trade of whaling. In 1893, she sailed her way down the St. Lawrence River and the Great Lakes to Chicago, and was placed on exposition. She was later sold and broken up, ending her grand career.

Flat-bottom boats were also built on the banks of the Pawcatuck River. This style vessel was very popular, being able to operate in the shallow water of the Pawcatuck. These flat-bottom scows, fitted with mast and sails, were used to lighten vessels of coal, which were unable to come up the river in shallow water. In 1856, one such flat-bottom boat was built at the Greenman Shipyard for the purpose of dredging the Pawcatuck River. This flat-bottom and square-ended scow was 26 feet by 40 feet and powered by four horses. It was in service on the Pawcatuck River for a short time then sold to a Norwich party and steam power was installed.

The last vessel to be built at the Greenman Shipyard was a three-masted, 400-ton schooner called the *Waterline*. The *Waterline* was launched in August 1874. This concluded one of Westerly's early industries.

In 1846, Orlando Smith, a stonemason, found indications of a good quality of granite on the farm of Dr. Joshua Babcock on Rhode's Hill, also known as Quarry Hill. Upon purchasing the property, he formed the Smith Granite Company and began what would be the beginning of Westerly's granite industry. The Smith Granite Company quickly grew as the demand for the stone increased, and facilities such as a polishing shed and a machine shop containing pneumatic tools, saws, and pumping and hosiery machinery were soon added.

Over time, other companies were formed and began quarrying stone in Westerly. Among these companies various kinds of granite were quarried, such as blue, red, white, and pink. Used for building, blue granite was in large demand, and pink granite was used mostly for statues and monuments. The value of Westerly granite is evident in its use in numerous buildings and monuments across the county. An example of such is the Soldiers and Sailors monument in Providence, the National Monument at Gettysburg, and the Congressional Library in Washington, D.C. The Westerly granite industry employed as many as 700 at times and is a source of great pride to this area.

One

Around Town

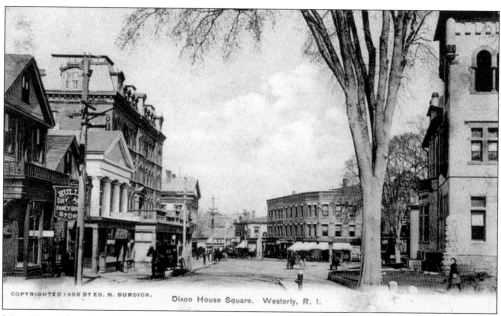

Mrs. Tom Thumb, widow of Gen. Tom Thumb who died in 1883, stopped at the Rhode Island Hotel on Broad Street on Sunday, December 12, 1915. She appeared at one of the local theaters that week. The little coach, which was presented to Gen. Tom Thumb by Queen Victoria, arrived on December 13 at the Westerly Station by express and was exhibited at the hotel. Several years prior, the Thumbs came to Westerly for a theatrical engagement and they rode from Westerly Station to the Dixon House in this same coach, attracting much attention.

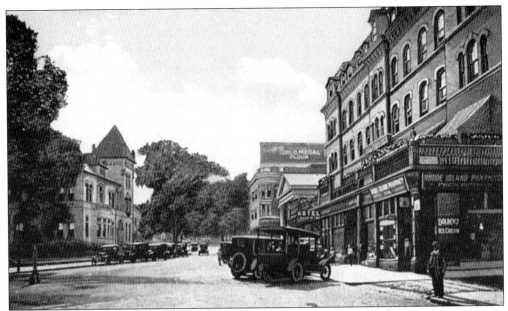

A disastrous fire swept through Westerly's business section in the early morning hours of February 13, 1910, threatening to destroy the central part of town. After a fierce fight, the fire was brought under control and extinguished after it had consumed two business blocks, three residences, and a large stable. The First Baptist Church and the Dixon House were also damaged. The fire ignited 10 tons of hay, contributing to the fire's fury.

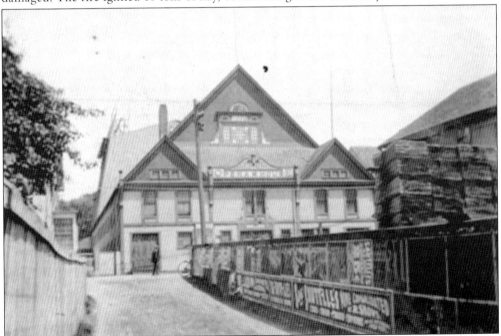

The Bliven Opera House was constructed in 1884 by C. B. Bliven. Its seating capacity and stage, one of the largest in New England at that time, nicely accommodated the many repertoire stock companies that toured New England. The structure also hosted many town meetings and public rallies.

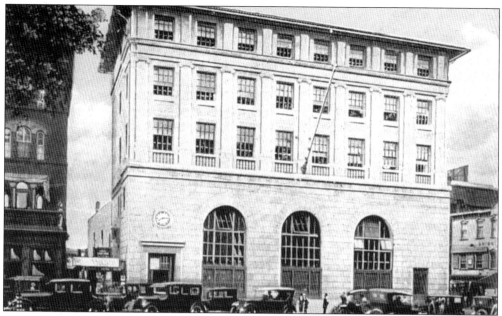

The Washington Trust Company, founded in 1800, provided the area and its growing economy with a sound financial institution. Other financial institutions conducting business in the Westerly area at the beginning of the 20th century were the National Niantic Bank, which was organized in 1854; the Westerly branch of the Industrial Trust Company of Providence; the National Phenix Bank of Westerly, organized in June 1818; and the Mechanic's Savings Bank.

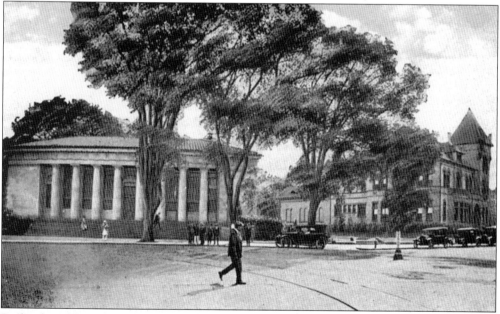

Built of marble and granite in the Doric style of Greek architecture, with a radial front and terra-cotta roof, the post office sits majestically in the heart of Westerly. When the construction was finished and the building opened to the public, some 3,000 people gathered to inspect Westerly's new structure. The structure has a cornice of veined white Vermont marble and was colored a matte-glazed terra-cotta, ornamented with lion heads.

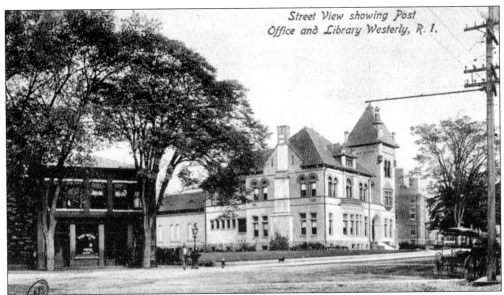

Prior to the construction and opening of the new post office in 1914, this quaint two-story brick building on the left served as quarters for the postal service of Westerly under postmaster Frank E. Rich. This brick building was razed in 1912 to make room for the new structure. Previously the postal service was located in the Dixon House under postmaster Enoch B. Pendleton. In Revolutionary times, Joshua Babcock conducted an office before 1776, when he received his appointment from Benjamin Franklin, postmaster general. (URI.)

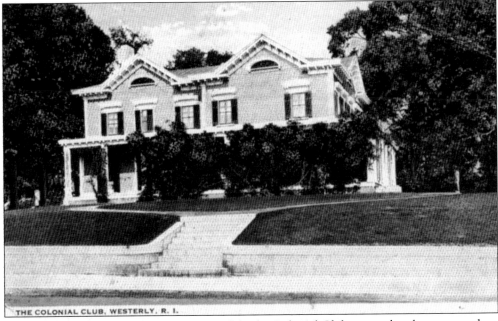

On Tuesday, July 2, 1912, Westerly's new club, the Colonial Club, opened and many members gathered to inspect their new clubhouse, formerly known as the Brown Mansion on High Street. Decorated throughout with large bouquets of flowers, many enjoyed refreshments and the sounds of instrumental and vocal music. Enthusiasm was abundant as its members dedicated the clubhouse for social purposes and used the property for club activities.

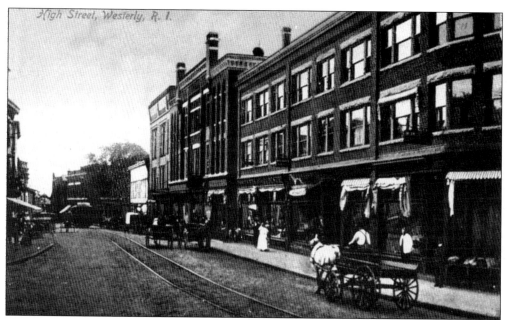

In September 1900, T. J. Welch's runaway coal wagon caused a stir in town. The horse pulling the wagon was spooked, causing him to run and pitch the driver, a Mr. Brown, down between the crosspieces and the horse's heels, dragging him a distance before letting go. The horse proceeded down Railroad Avenue when it slipped on the trolley car tracks and slid some 30 feet. Brown was picked up unconscious and bruised and was taken to his home where he made a full recovery.

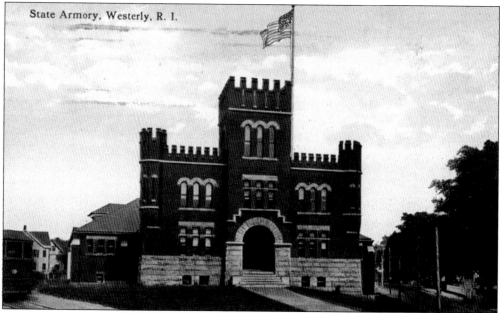

The public took its first look at the new armory building on November 4, 1902. The new armory of Company E, First Regiment Infantry, was inspected by a large group of people, and then they gathered in the drill hall to listen to the orchestra that furnished music for dancing. Everyone praised the new armory.

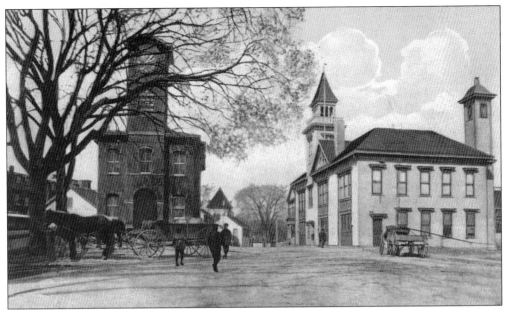

The building to the left is the old town hall on Union Street. The basement was used as the police headquarters and station house. The first floor was the town clerk's office, and the second floor was the town hall. The building on the right was the firehouse, which housed three companies: Engine Company No. 1, Engine Company No. 2, and the Alert Hook and Ladder Company. (WHS.)

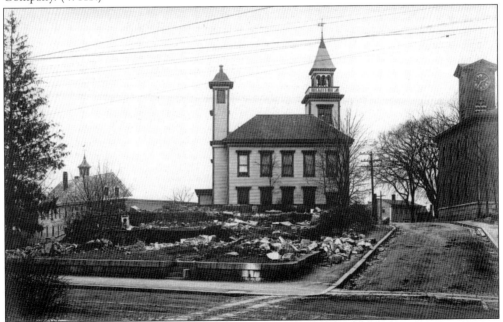

On February 13, 1910, a disastrous fire destroyed the Welch Building at the corner of Broad and Union Streets. Many felt the location would be an ideal spot for the new town hall, and negotiations began for obtaining the property. The building in the background was the firehouse, built in 1894 and destroyed by fire in 1927. The belfry housed the largest bell in town and was used as the town's fire alarm. (WHS.)

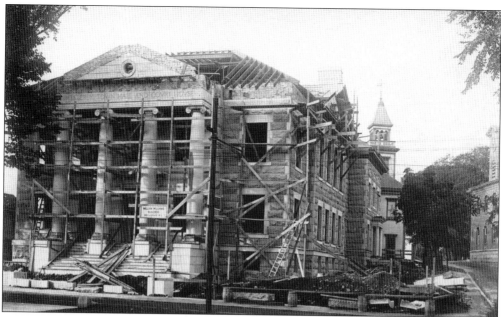

The town hall and courthouse, built of Westerly granite, opened to the public in June 1913 and sits majestically on the corner of Broad and Union Streets. The town hall was built in conjunction with the new courthouse by an appropriation of $80,000 from the town and $50,000 from the state. By joining the two structures, the town was able to get one magnificent granite building, which exemplified the industry from which Westerly has become famous. (WHS.)

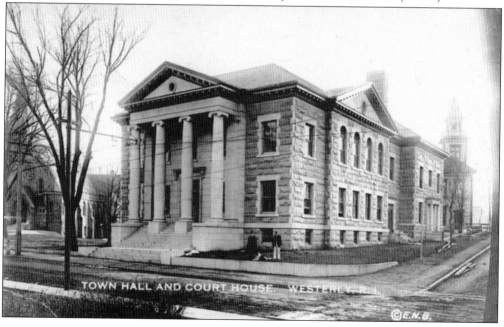

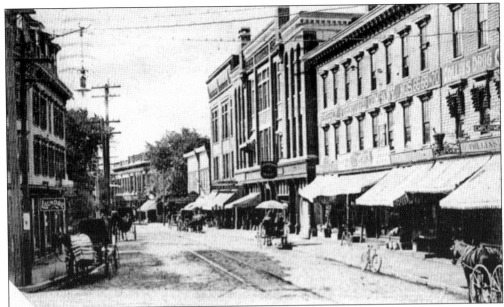

Breathtaking theatrical acts were frequently performed for the entertainment of those who patronized Blivens Opera House. However, in November 1900, Howard Tefft, a stagehand who was some 46 feet above the stage, fainted and caused many in the audience to gasp in horror. It was the quick thinking of his brother Walter, who was also working on the gridiron, who saved his life by grabbing his arm before he fell to the stage below.

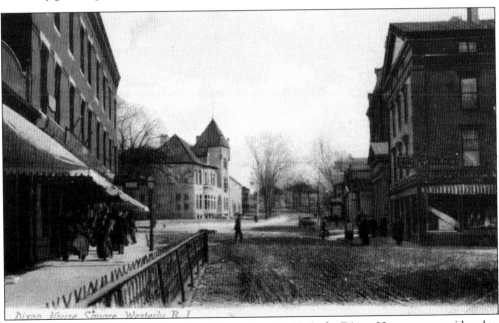

Constructed in 1866 and opened to the public on June 18, 1868, the Dixon House was considered to be the largest and most modern hotel in the state. At the time, the *Providence Journal* acknowledged this fact and congratulated Westerly in its business section on having such a magnificent building. Over 1.5 million bricks, 800,000 feet of lumber, and 90 tons of iron were used in the construction of this building.

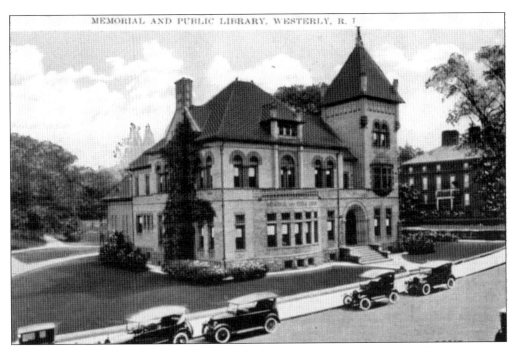

The town of Westerly has always been proud of its men who served in the Civil War upon the call of Pres. Abraham Lincoln. To honor those brave men and their deeds of valor, a magnificent memorial building was constructed in 1894 and dedicated in their honor.

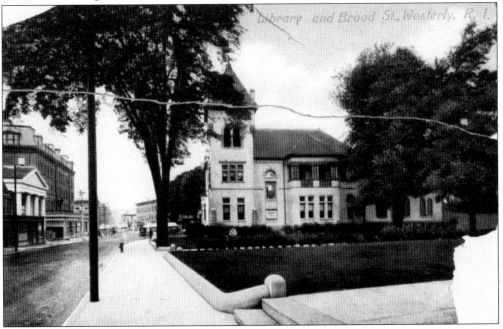

Elm Street. Westerly, R. I.

On a Friday afternoon in February 1913, Mrs. Orville Randolph heard a loud knock coming from the back door of her home on Chestnut Street. As she neared the door, the visitor quickly entered and there she stood face to face with a horse in her kitchen. A coal team had come to deliver a load when the horse broke free and slid down the icy steep incline from Rocket Street toward the house and then into the kitchen.

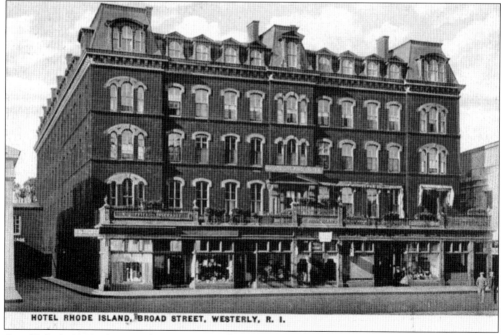

HOTEL RHODE ISLAND, BROAD STREET, WESTERLY, R. I.

As of July 1, 1913, the popular landmark known as the Dixon House was renamed the Rhode Island. The name changed when the new owner, William Segar, completely renovated the hotel's interior. The furniture was reupholstered, new lace curtains were put in place, the walls were repapered, and the floors were thoroughly cleaned and brightened.

In November 1902, the Thompson Automobile Company of Providence began a bus service in Westerly. The large passenger bus was powered by steam and could carry 25 people. Many residents disliked the steam bus, declaring that it was a nuisance. The steam from the bus frightened farmers' horses, thereby causing runaways, which resulted in damage to wagons, carriages, and the like.

The Westerly Automatic Telephone Company began service in Westerly on October 19, 1902, with nearly 50 phones connected and ready for business. This new system did not require an operator to perform a manual connection. Many residents were bewildered by the new machines with a dial, as they were accustomed to the familiar crank and pleasant voice asking "Number please." The cost for a year's service was $24, or $15 for a party line.

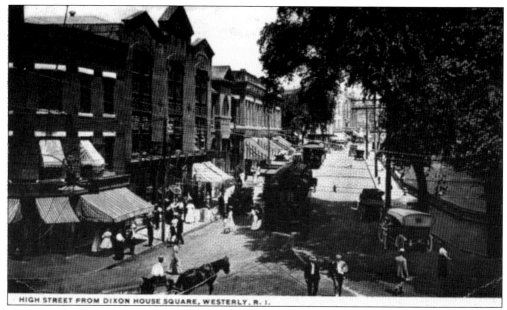

HIGH STREET FROM DIXON HOUSE SQUARE, WESTERLY, R. I.

A severe lightning storm on May 27, 1907, caused havoc in Westerly. A bolt of lightning struck the guy-wire on the trolley leaving downtown, doing minor damage. Many in the vicinity of Dixon House Square watched as a ball of fire danced between the two wires of the trolley line. Walter Merrill of North Stonington was also thrown off his wagon when a flash of lightning struck close by.

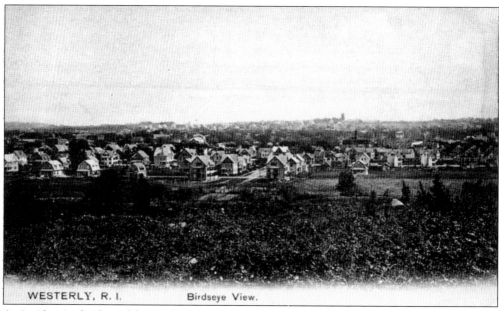

WESTERLY, R. I. Birdseye View.

An incident in the days of the Civil War brought Westerly a little closer to its beloved Pres. Abraham Lincoln. In the later part of 1862, the Ninth Regiment, Rhode Island Volunteers, many who were from Westerly, were awaiting transportation at the arsenal in Washington when they recognized the tall form of the president. They quickly formed a line and greeted Lincoln with a round of cheers. Lincoln made a short speech, and many felt it to be a benediction carried home to Westerly.

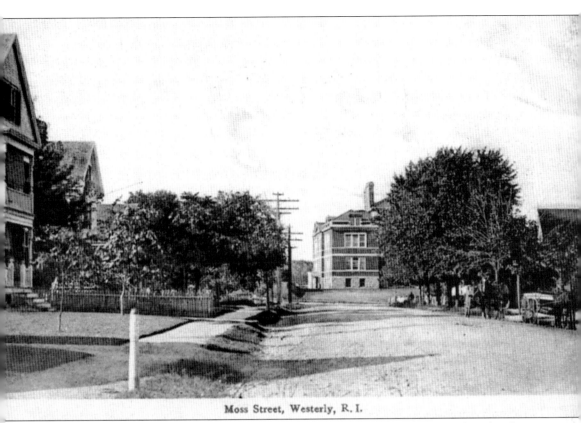

Moss Street, Westerly, R. I.

William Pickering won the first heat of horse racing with Redit, but Smokey took the other four heats on a cool Wednesday afternoon in February 1907. Local horsemen frequently gathered as the best trotters in town took advantage of the good condition for racing on Moss Street. Horses from the surrounding towns would also be brought in to try their luck in these third-of-a-mile heats from West Broad Street down Moss Street.

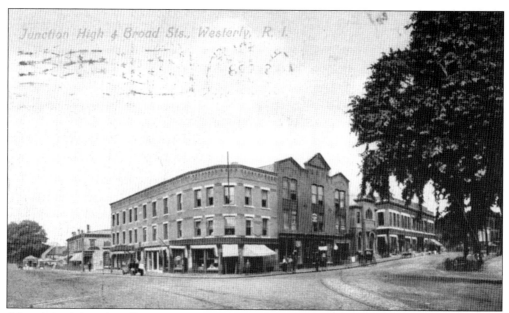

A good deed done by officer Edward E. West on October 23, 1899, is not forgotten. While on duty in Westerly's business district, he was approached by a soldier boy who was tired, hungry, homesick, penniless, and unable to proceed any further, but he found a friend in the policeman. A good, square meal was acquired for the young man, and a pool was formed to purchase a ticket to send the boy home.

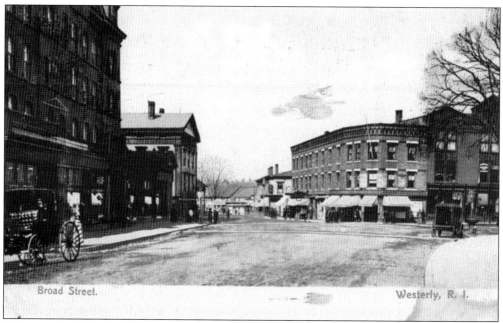

William Slocum of Preston lost a brindle cow that wandered off in December 1899. He searched for weeks, tiring out his horse and his patience. He then decided to advertise in the local newspaper and sent 25¢ to the *Westerly Sun* to place an advertisement. Within days the brindle cow was back in Slocum's barn.

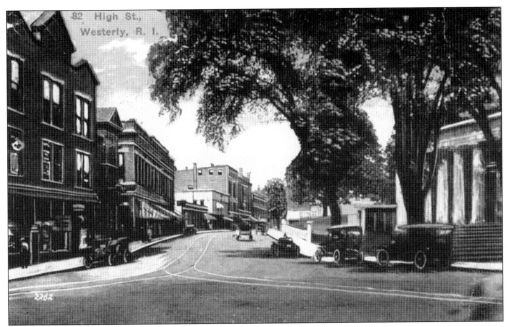

On August 8, 1909, W. R. Rook announced to a reporter for the *Westerly Sun* that his street-sprinkling cart would no longer appear on the streets. He claimed that since the town had been oiling the streets, the sprinkling business had not been a paying investment. The water cart was greatly missed in the business portion of town.

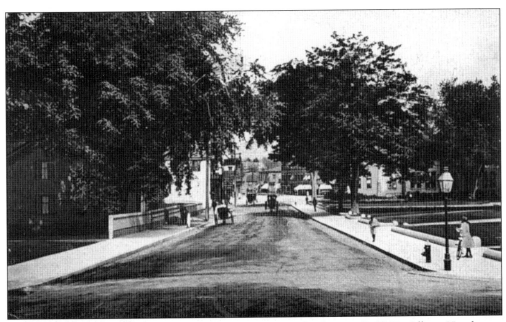

"Where's the beef," many wondered on the morning of February 5, 1900. Albert Henderson was on his route, delivering meat from his cart on Mechanic Street when he stopped near the home of John Lueck. The horse attached to the cart had become spooked, starting him on a lively run. To Henderson's dismay, the delivery meat had spilled out along the way.

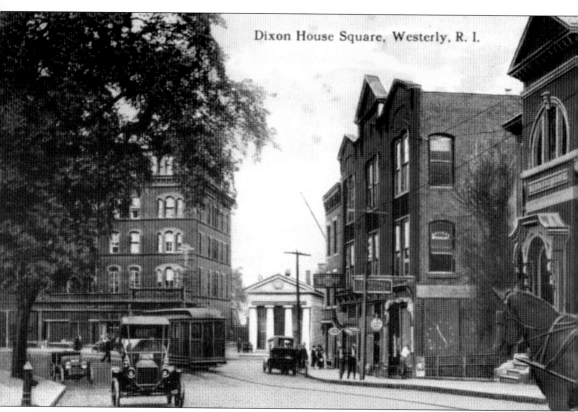

In an annual event held on July 30, 1903, people gathered at Dixon Square to watch the arrival of the Gentry Brothers Circus and a street parade. Included in the parade was a pony cart, a bandwagon drawn by ponies, cages of monkeys, wagons of performing dogs, and many peculiar circus folks. The camels and trained elephants also followed along as the entourage headed to the old circus lot on Liberty Street.

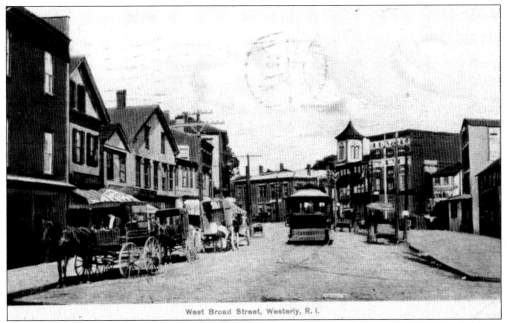

West Broad Street, Westerly, R. I.

The old saying "the money was burning a hole in his pocket" came true in January 1919. While one of Westerly's residents was on his way to the town hall to pay his water tax, a pedestrian smoking a cigar unknowingly rubbed his cigar against the coat of the taxpayer. When the taxpayer arrived at the tax office he reached in his pocket and found his money smoldering and his pocket burned.

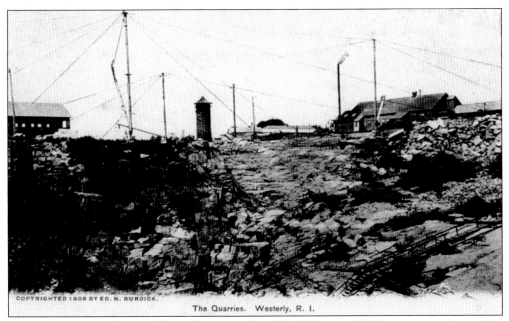

The Quarries, Westerly, R. I.

In the early days, White Rock was known as Crumb's Neck, so called because a portion of the land that juts into the river was owned by Sylvester Crumb. Privileges to the mill were sold to Blodgett, Stafford, and Simmons for $1,300, and at that time, a white rock was found in the river, so the company took the name the White Rock Company.

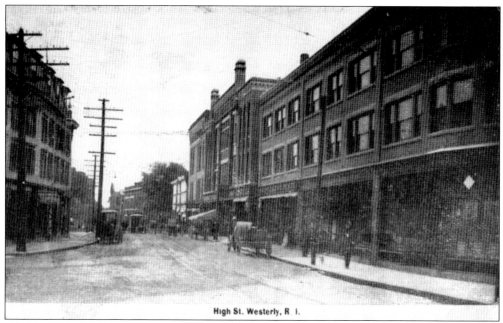

High St. Westerly, R. I.

The rising temperature and rain on January 7, 1910, made for a slippery day in Westerly. Many kept their horses that did not have sharp-calked horseshoes stabled. Due to a lack of traction, Dr. M. H. Scanion's horse fell on West Broad Street. It took many people to get the horse back on its feet and to the blacksmith's shop for a new set of calks.

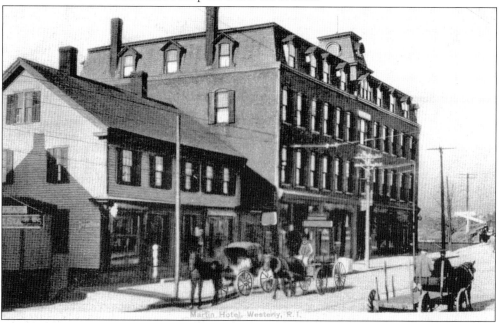

Martin Hotel, Westerly, R. I.

In March 1908, Emery Hodge was walking along the railroad bridge, which was not far from the Martin Hotel, with friends. Not hearing the train coming, Hodge jumped from the bridge into a barrel as the train thundered past. His friends soon saw that Hodge escaped one death only to battle with another. The barrel he jumped into head-first was filled with water. Pulled from the barrel unconscious, he quickly recovered and escaped death a second time.

Two

Along the Shore

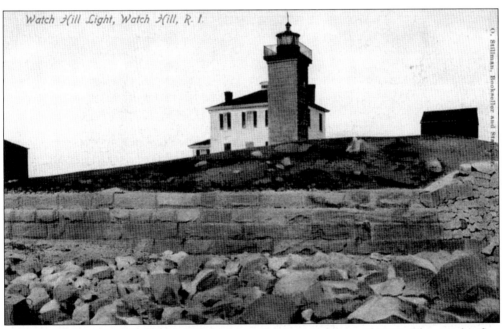

J. B. Young, keeper of the Watch Hill Light, took a vacation in April 1909. This was his first vacation in eight years from his duties. All that time he had diligently looked after the light, keeping it burning from one year to the next. An assistant keeper was hired to help with the light and other duties while Young took his well-deserved rest.

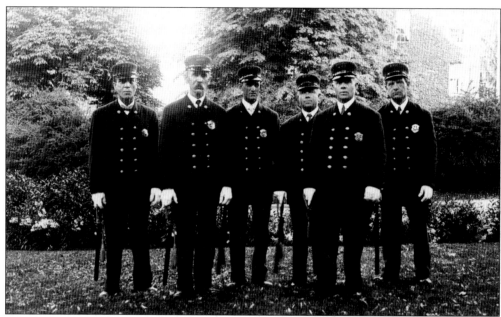

On a Friday evening in May 1900, officer Charles H. Fay came across a horse and wagon while making his round at Watch Hill. The night air was chilly, and the poor animal shivered and shook. One of the horse's legs had wandered over the wagon's shaft, forcing him to balance on just three legs. With his lantern, the officer went in search of the owner and found him nearby digging a hole near East Beach. The man and his brother explained excitedly that they had secured an "intelligent rod" and that the device could detect gold and silver more than 50 feet away. They believed that they could finally find the elusive treasure buried so long ago by that notorious sea pirate Captain Kidd. The spot at which they were digging, they explained, was where the magic rod became hysterical, and it was there that their spade and shovel went to work. It was said that the next day a box was unearthed, but police records do not contain any such information. (WHS.)

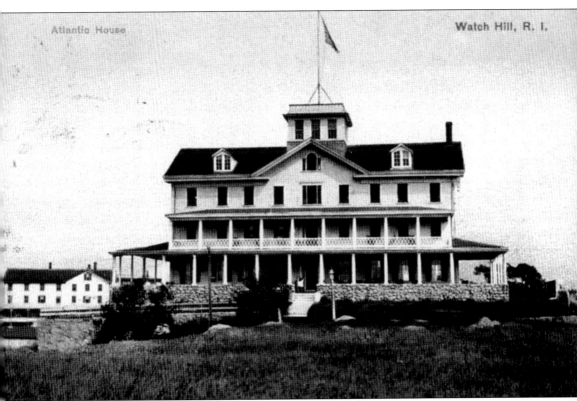

On September 8, 1913, a severe lightning storm hit Watch Hill in the early morning hours, striking several places, including Mapes Cottage and the Blackler House. One lightning bolt hit the flagpole on the top of the Atlantic House, completely shattering the pole. Luckily the rest of the structure escaped the storm's wrath. Before leaving, the electrical storm put many residents' telephones and electricity out of commission.

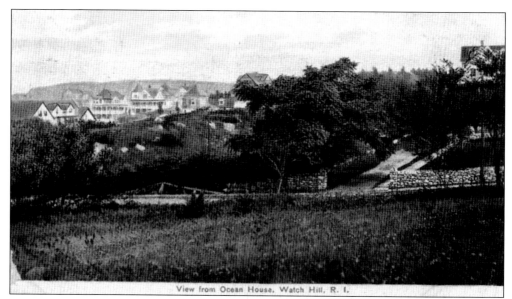

Enormous amounts of ice were needed daily at Watch Hill. It was announced that J. Frank Champlin, proprietor of the Ocean House, who was unhappy with the quality and quantity of natural ice, installed a small ice plant at the hotel. He hoped the artificial ice would be more pleasing to his guests and expected that the plant's output of eight tons per day would meet their needs.

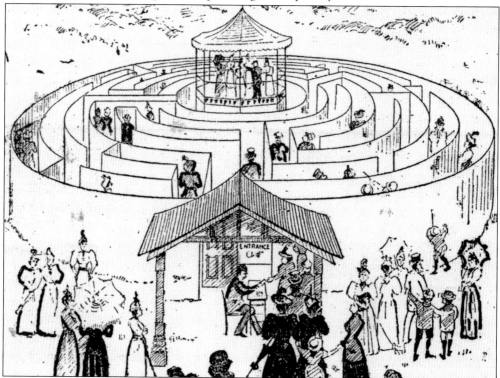

In July 1900, Charles H. Atkinson of Boston erected his maze on Bay Street. Admission to enter the maze was 10¢ and was reported to be a more enjoyable 30 minutes than one would have ever before experienced and the greatest novelty of the age.

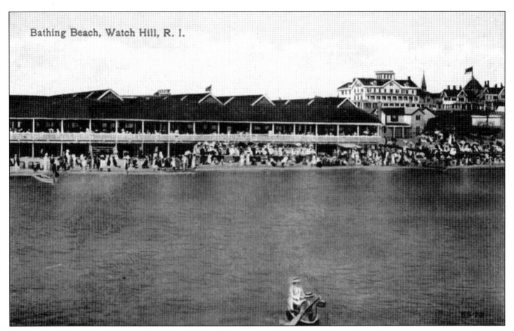

As reported on April 30, 1899, Frank Larkin, owner of the bathing beach property at Watch Hill, contracted for the erection of a new bathhouse containing 90 rooms. A nicely shaded piazza was also built to adorn the ocean side, where people could sit and watch others enjoying themselves along the soft, white, sandy beach at Watch Hill.

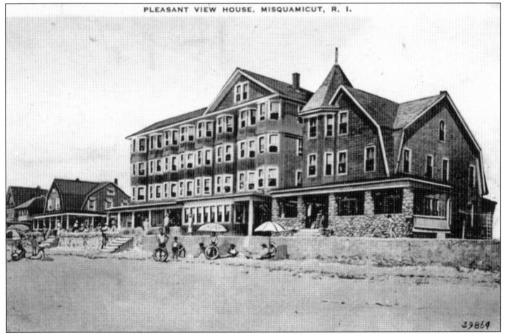

A coastal storm swept into Pleasant View on March 1, 1914, and in a short time over half the buildings along the storm-swept beach were seriously damaged or destroyed. It was reported that every cottage from the Pleasant View House on the west end to the John Nichols cottage on the east end was affected and had to be moved back.

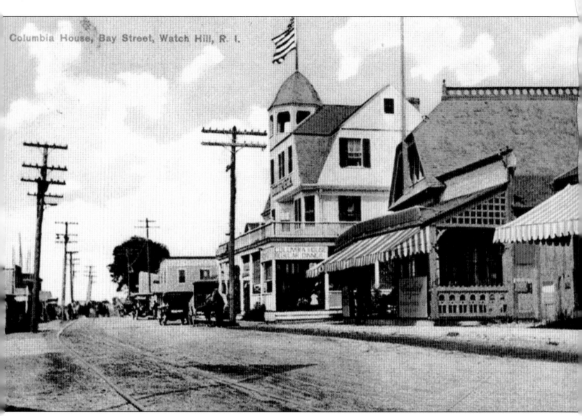

It was announced on May 1, 1911, that a new vaudeville house would be opened on Bay Street, opposite Frank Larkin's office at Watch Hill. Charles H. Cowan Jr., proprietor of the Star Theater on Broad Street, hired R. A. Sherman and Sons Company to erect the building. It was reported that the theater's interior was 30 feet by 60 feet and fully equipped for vaudeville purposes.

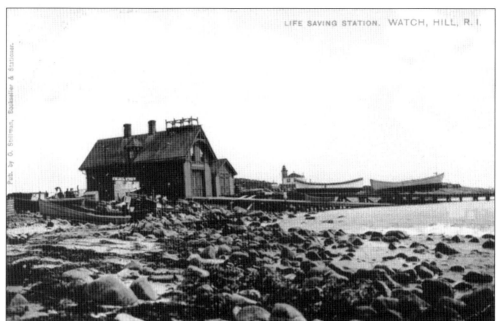

An inspection by Henry E. Davis of the Life Saving Service in April 1901 found the old station at Watch Hill to be hardly habitable and recommended a new structure be erected. He believed that lifeguards at Watch Hill did a wonderful job and deserved an up-to-date structure.

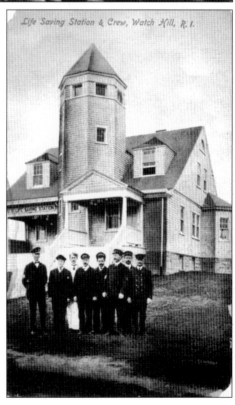

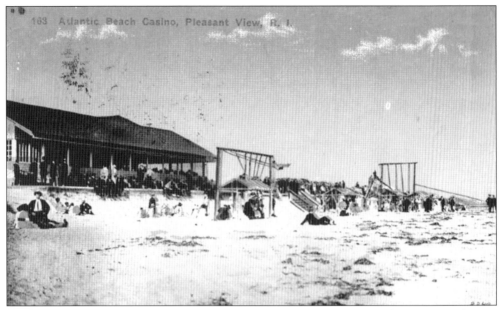

On April 16, 1911, it was reported that the groundwork had begun for the casino at Pleasant View. H. T. Kenyon and Company of Westerly was hired to erect the new pavilion. The building was 70 feet by 25 feet, with a piazza and balcony on the front and west sides. A large part of the building was framed at the yards of H. T. Kenyon and Company on Main Street and moved to Pleasant View.

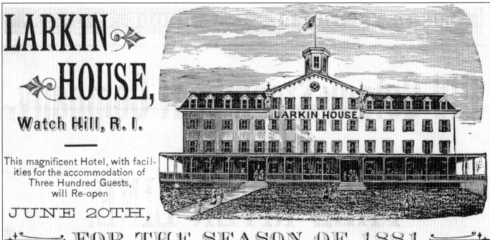

George W. Steadman, while walking on Main Street on Tuesday, July 5, 1904, noticed an electrical wire laying on the trolley tracks with an electric trolley car approaching. He picked up the wire and wrapped it around a tree as the car passed, but to his misfortune the car caught the wire, pulling it and shocking him. A doctor took him home, and he quickly recovered.

A View looking towards Watch Hill, Pleasant View, R. I.

On May 30, 1909, it was reported that several people from Westerly might have witnessed a tragedy. At 2:00 p.m. a large balloon was seen to the south, not far from Pleasant View, and was drifting rapidly out to sea. Several signaling lights were seen coming from the basket below the balloon, which swayed wildly in the wind. Where the balloon came from or what happened to it is a mystery.

Cottages at Pleasant View Beach, R. I.

The Plimpton House, Watch Hill, R. I.

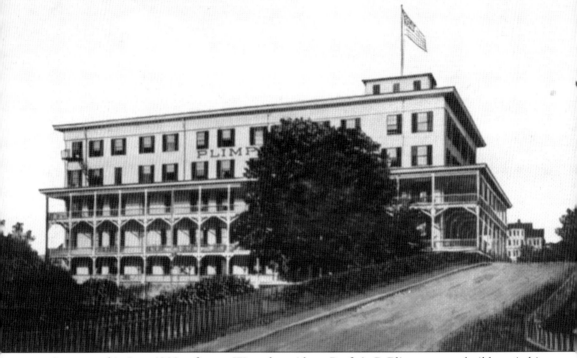

As reported in June 1908, a former Westerly resident, Prof. A. P. Bliven, was to build an airship capable of unlimited voyage that could fly through the air at high speed and revolutionize modern warfare. He had secured land near Fort Trumbull, Connecticut, for an aerodrome. His first airship was to be called the *Yankee Bird*.

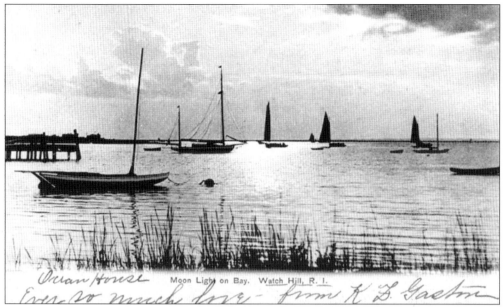

On the evening of August 27, 1905, the people of Watch Hill were treated to a rare sight off shore. The fleet of the U. S. Navy had anchored off the coast of East Beach, including the battleships *Maine*, *Missouri*, *Kentucky*, *Kearsarge*, *Alabama*, *Illinois*, *Iowa*, and *Massachusetts*. In addition, some 25 searchlights from the ships threw their beams upon the sky, beach, and cottages. It was said to be grand.

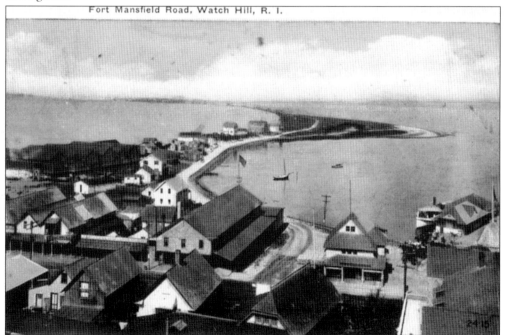

Formidable Fort Mansfield was nestled in the sand at the end of a long peninsula at Watch Hill. The fort was first manned in early 1901, boasting two eight-inch disappearing Crozier guns that took a 350-pound shot backed by 150 pounds of Dupont powder, and had a destructive range of more than seven miles. Many other large-caliber guns complemented the fort's defense.

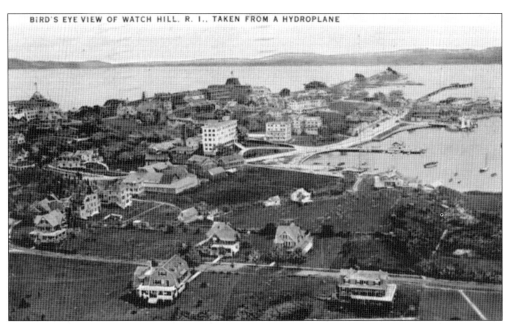

On August 25, 1913, large crowds along the beaches of Watch Hill stared skyward, many spellbound from seeing the gentle graces of a flying machine for the first time, which then landed majestically upon the ocean. The Curtis 100-horsepower "flying boat," with aviators William Thaw and Steve MacGordon, stopped at Watch Hill on its way from New London to Newport. Upon departure, many straw hats were blown off as the spectators merrily chased after the flying machine.

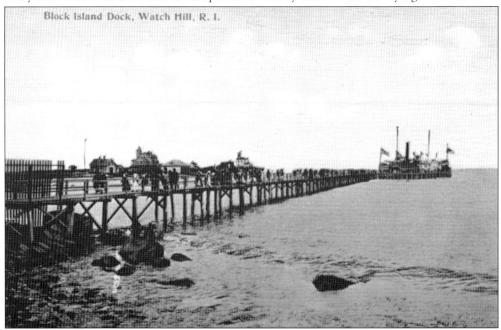

In June 1908, the pier at Watch Hill underwent reconstruction with some noted improvements. The pier had been badly damaged by a storm that tore off a large part of the dock. The rebuilding of the pier to accommodate seasonal visitors was of the utmost importance. Many were pleased to see changes to the shore-end of the dock and new decking.

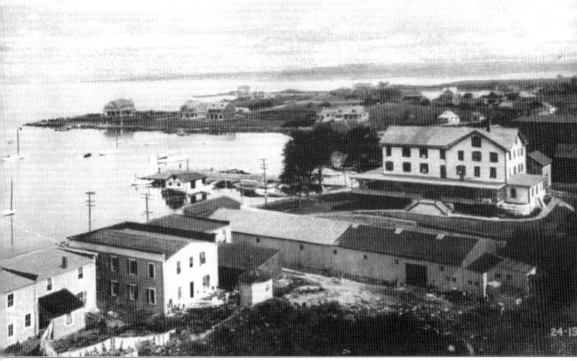

The tugboat *Battler*, with three barges in tow, lost her rudder off the coast in April 1909. The *Battler* had left Providence through Narragansett Bay to head toward New York but became unmanageable off Watch Hill. Barges were brought up alongside the *Battler* to aid in steering, and with some help from a towboat fleet, the *Battler* once again continued on her way.

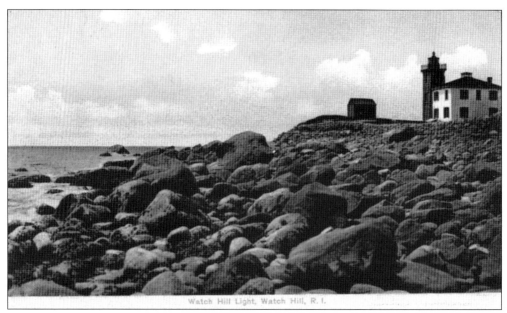

Watch Hill Light, Watch Hill, R. I.

On October 12, 1908, the newest and finest lighthouse tender made her first appearance at Watch Hill light. The *Tulip*, a 185-foot ship constructed of steel, was commissioned on July 14, 1908, to serve the third lighthouse district, which extended from New York to Newport, Rhode Island. The *Tulip*'s engines were rated at 1,000 horsepower, which could propel her at a speed of more then 12.5 knots per hour.

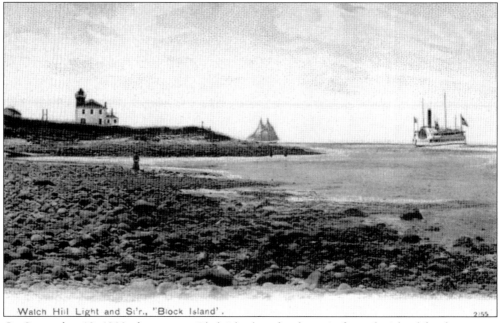

Watch Hill Light and St'r., "Block Island".

On September 13, 1903, the steamer *Block Island*, on her last trip from the island for the season, almost became stuck on the sand off Watch Hill Beach. That evening the fog was exceptionally thick, and she lost her reckoning as she came around Watch Hill Point blowing her fog whistle. The steamer passed her regular landing place and entered shallow water where she hit the sandy bottom but was able to back off, apparently undamaged.

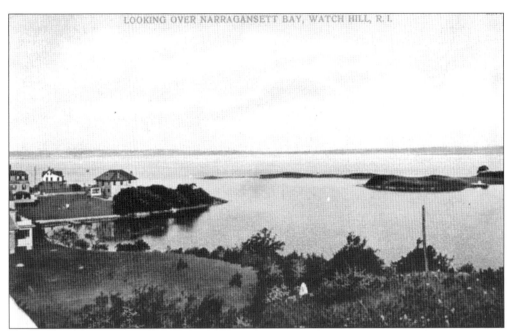

On July 10, 1914, Captain Hazzard of the steamer *Block Island* reported that during the past week he had passed whales between Watch Hill and Block Island. He stated that he saw one 40 feet long within two boat lengths of the steamer. Schools of porpoises had also been noticeable, with four or five schools seen in a single day.

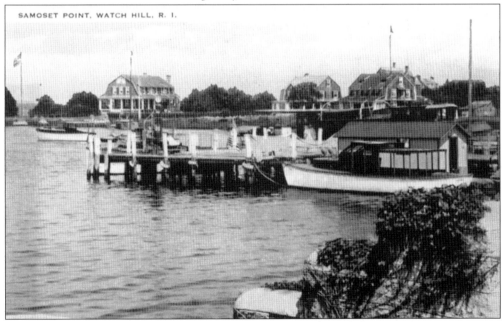

The new rotary pump, an invention by Herman Dock of Watch Hill, was tested on the dock of the old Marvin place on April 8, 1914. Several Westerly residents and experts from out of town looked on during a 100-hour test a few days later and admired the new pump in action. They stated that this new fire pump was revolutionary and performed better than any other pump available.

On March 27, 1913, one of the worst storms of that season swept the Atlantic coast and threatened the entire South County, Rhode Island, seaboard with high seas and terrific gales of wind. The conditions became so alarming at Fort Mansfield that help was summoned and soldiers from Fort Wright on Fisher's Island rushed to Watch Hill. The soldiers began piling up rocks where the enormous waves had broken through the seawall and threatened the entire fortification.

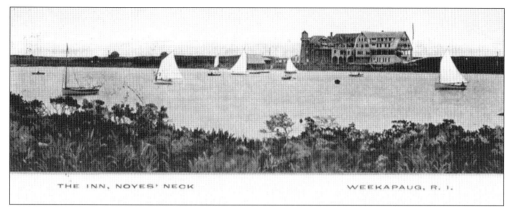

THE INN, NOYES' NECK WEEKAPAUG, R. I.

As Westerly's beaches became popular for those desiring a quiet and healthful place to spend their summer, many fashionable and expensive resorts and hotels were built. At Noyes Beach the Weekapaug Inn was built and opened its doors on June 15, 1899. The beautifully constructed inn had all the modern conveniences to accommodate its many guests.

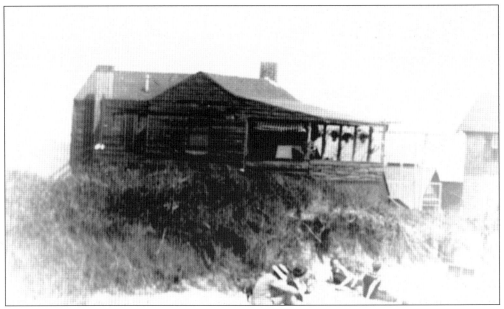

A violent storm on December 1, 1913, with the highest surf ever reported on the beach did considerable damage to the Log Cabin and the Taylor Cottage at Weekapaug. At the time the breakers were the highest, photographer Walter Rogers and Mrs. Frank Maxson were on the piazza of the Log Cabin. They were reportedly terror stricken when they saw a huge breaker heading for the cottage.

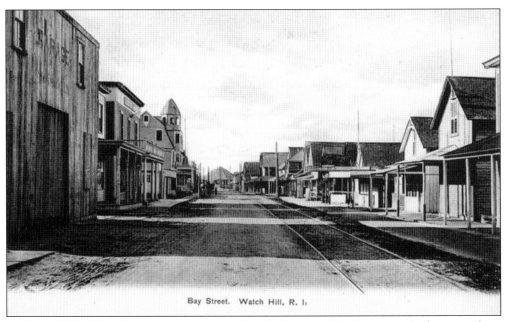

On July 17, 1904, Joseph Pendleton, employed by the Pawcatuck Valley Street Railway, was bent over oiling the tracks in Watch Hill when he was struck by an automobile and thrown. Being uninjured but slightly dazed, he collected his thoughts and paced back some 25 feet to where he had been oiling. He recalled later that he had to retrieve his oil pail from 100 feet away.

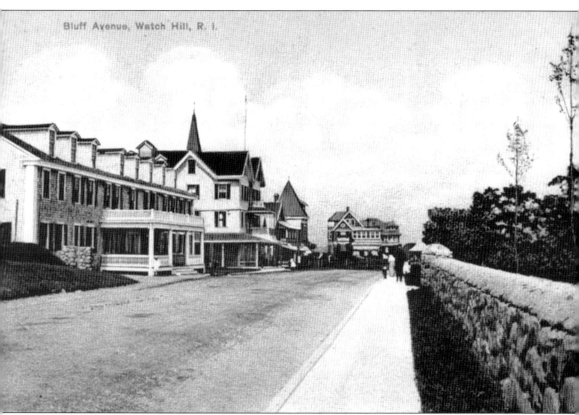

A number of local automobile owners who had cars for hire during the summer season of 1915 dropped their fares for a trip from Westerly to Watch Hill. Due to increased competition, the standard rate for local service was dropped from 25¢ to 5¢. The rivalry made travel about town a bargain for the people that depended on the jitney for their transportation.

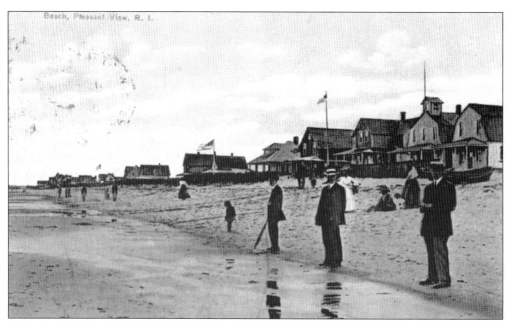

In seeing a peculiar glare from a steamship off the coast on a clear day in April 1912, the lifesaver sprang into action. The steamship *Ontario* had caught fire and was ablaze when the lifesaver from the Watch Hill Life Saving Station arrived. It was acknowledged days later that thanks to the watchfulness of the lifesavers a calamity had been averted.

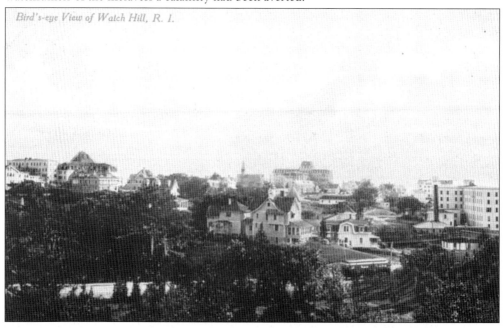

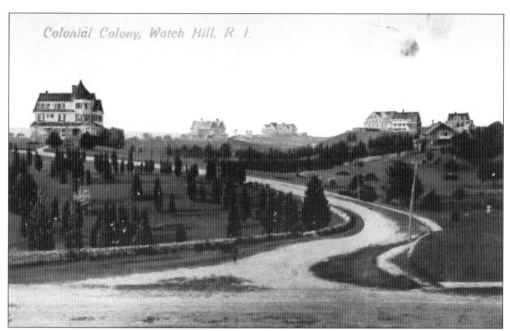

Due to the big touring cars of the day, the state board of public highways experimented on Shore Road in November 1907. A scheme of mixing tar with crushed stone was tried and found successful. The macadam made a fairly good road that took the abuse of the many powered vehicles and contraptions being driven.

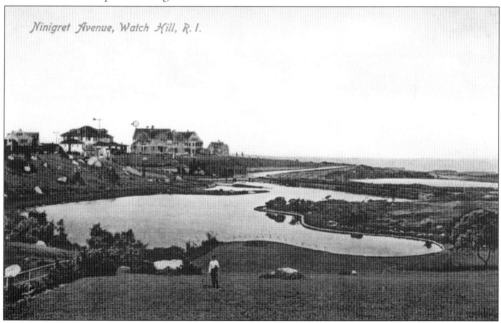

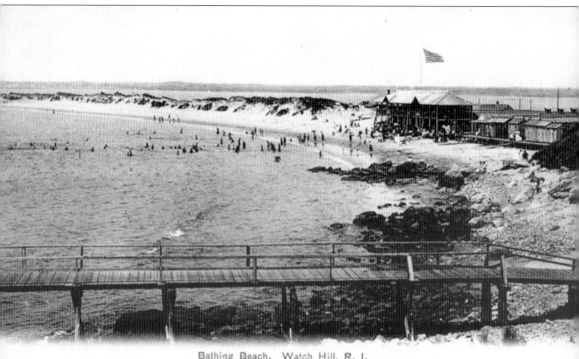

Bathing Beach. Watch Hill, R. I.

The pier at Watch Hill was constructed as a landing place for the steamer *George R. Kelsey*, which was opened to the public on July 19, 1881. The *George R. Kelsey* stopped at Stonington, Connecticut, connecting there with the steamer *Belle* to accommodate the many Watch Hill patrons and those heading to Block Island. Previous to 1881, Watch Hill guests who wished to reach Block Island traveled by steamer out of Stonington. Docks of the Larkin and Plimpton houses also served as a proper landing spot for the many vacationers and day-trippers to Watch Hill.

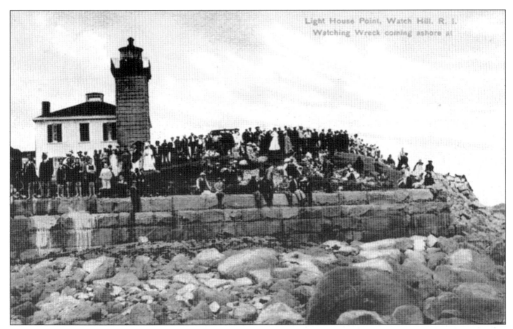

The Atlantic House showed off its recent improvements to the delight of the many guests in the summer of 1902. Electric lights had been recently installed, and the brightness and brilliance dazzled the old-timers. The house, when first built, was illuminated with sperm candles, then fluid, followed by kerosene, and then the magic of electricity. The manager of the Atlantic House in 1902 was C. W. Russell, who thought that each change in lighting had been an improvement but emphasized there was nothing better than sunlight. Many visitors to Watch Hill also noted the splendid light given forth from Light House Point that illuminated the night sky.

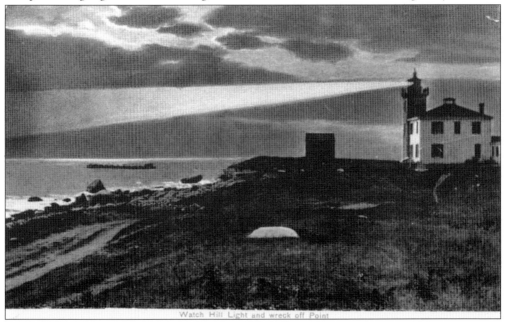

49

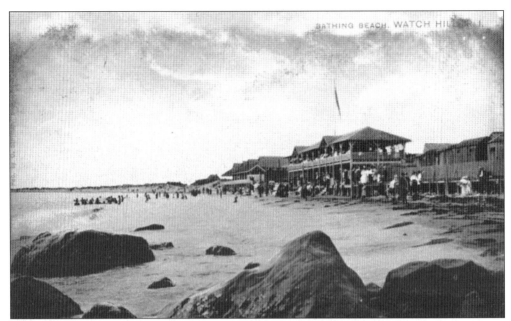

On November 3, 1899, Mr. A. B. Crafts and his wife, while driving on Beach Street, were thrown from their carriage by a collision with a lumber wagon. Crafts was driving Tip-toes, his bay gelding pacer, when after being passed by another carriage, Tip-toes suddenly began to run uncontrollably. The carriage struck the lumber wagon and overturned, ejecting the two without serious injury. The collision freed the horse, who returned home after a long run.

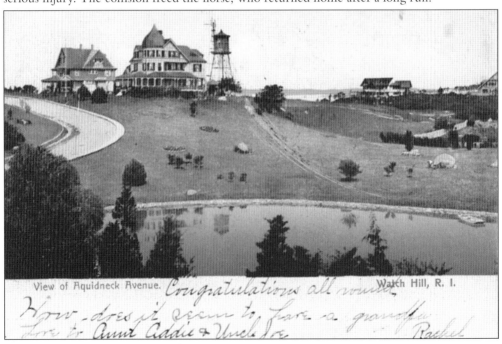

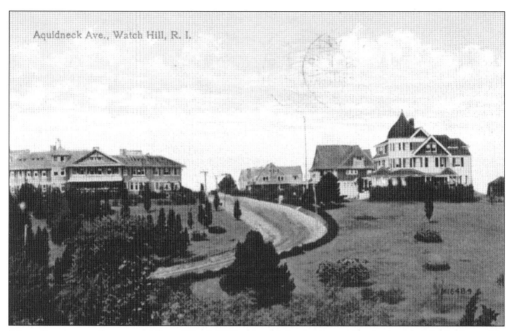

Many from around town and from Watch Hill enjoyed themselves at the skating rink in the Lorraine Building on West Broad Street. In 1907, the rink was enlarged and many other improvements added. A well-attended reopening of the hall was held on the evening of December 16, 1907. The large crowd enjoyed the roller skating and the music furnished by the Imperial Orchestra.

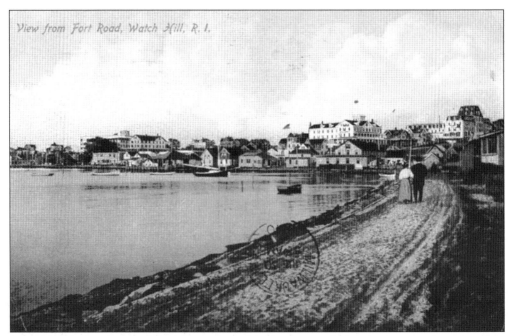

In May 1909, the government contracted out for the construction and reconstruction of roads at Fort Mansfield. The poor conditions of the roads hampered troop transport and supplies going to the fort. The new roads were a necessity to the keep the fort in a readied state.

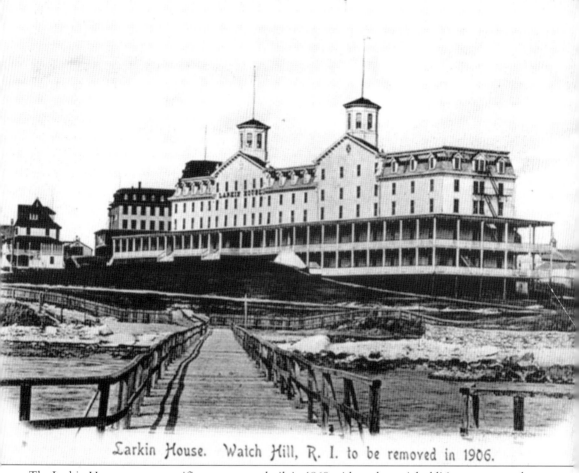

Larkin House. Watch Hill, R. I. to be removed in 1906.

The Larkin House was a magnificent structure built in 1869 with a substantial addition constructed in 1876. When it was torn down in 1906, the old lumber of the hotel was used in the construction of many houses throughout the town. Several houses on Pierce, Pond, and John Streets were built from the fine lumber from the prestigious Larkin House.

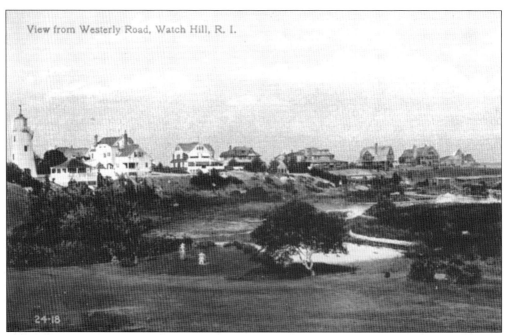

View from Westerly Road, Watch Hill, R. I.

Due to the warm winter, the ice harvest of 1906 was poor and the icehouses in the area emptied quickly. The price of ice jumped 100 percent to 60¢ for 100 pounds. Many in Westerly and at Watch Hill took it in stride and felt that, due to the warm winter, the coal man's loss was the iceman's gain.

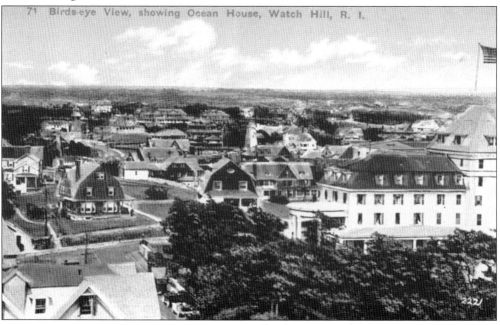

71 Birds-eye View, showing Ocean House, Watch Hill, R. I.

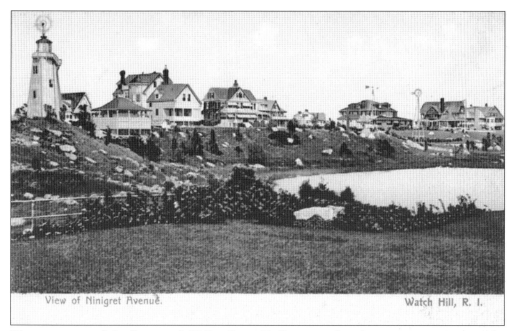

View of Ninigret Avenue. Watch Hill, R. I.

The motormen of the Pawcatuck Valley Street Railway stood at the post unprotected on the coldest days of the year as they drove their trolley cars between Watch Hill and Westerly. To remedy this, vestibules were installed on the platforms in October 1907, and heaters were also added to better the conditions for the motorman and his passengers.

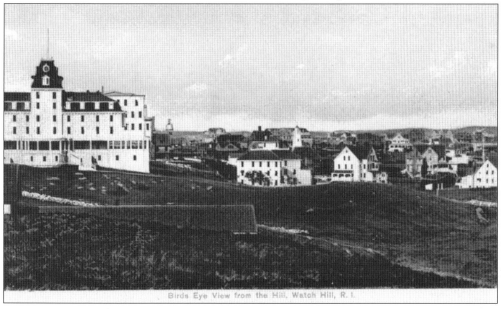

Birds Eye View from the Hill, Watch Hill, R. I.

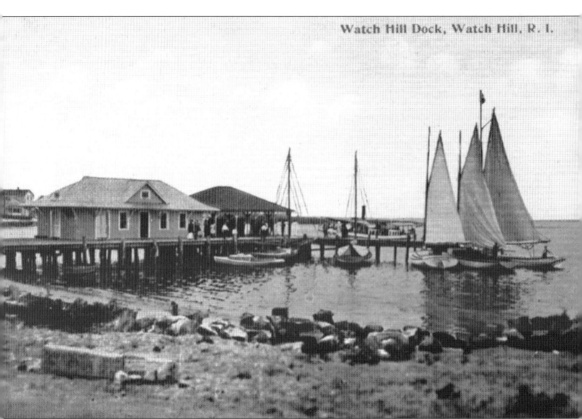

In the early days, a large number of those who came to Watch Hill arrived by steamer or yacht. At the opening of each season on the Larkin Dock a plank was procured about 10 feet long and one inch thick, under which three kegs were placed, forming a resting place. On this plank sat several of the captains and crews of the many yachts and steamers day after day during the season. While waiting for their patrons, each related what he knew and had observed. Each possessed a jackknife, and near the end of the season they whittled the plank with humorous remarks made by passersby going to and from the different steamboats at the dock. Many stopped to read this peculiar plank before they departed Watch Hill.

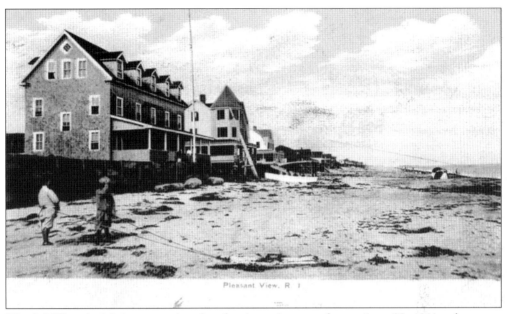

Watch Hill and vicinity was painted a glowing crimson color on June 29, 1911, when over 500 Harvard Alumni spent the night there. The loyal and enthusiastic crowds poured into Watch Hill in six special cars from the Pawcatuck Valley Street Railway. The alumni, which represented the classes of 1891, 1896, and 1901, formed a line at the foot of the Mastuxet Terrace and marched to the Watch Hill House headed by the First Corp Band of Boston.

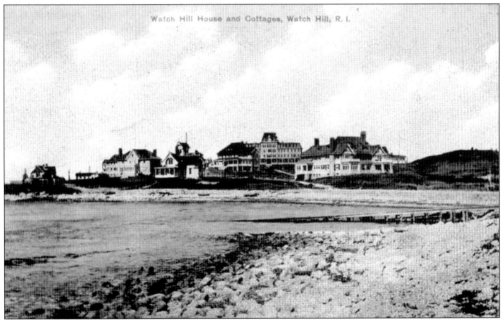

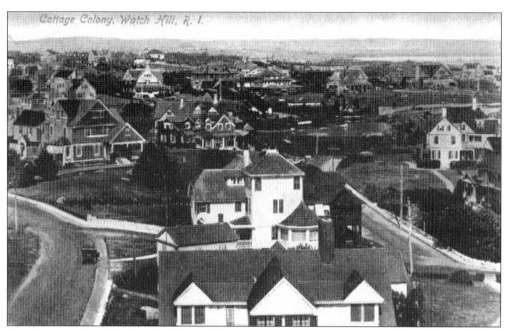

It was reported in July 1911 that the new law requiring those operating automobiles and carriages to drive on the right continued to be broken. Operators repeatedly broke the new law and drove on the left-hand side of the street in the congested sections of town. Those caught took their reprimands from the police in the right spirit but believed the new law too restrictive of what they were accustomed to.

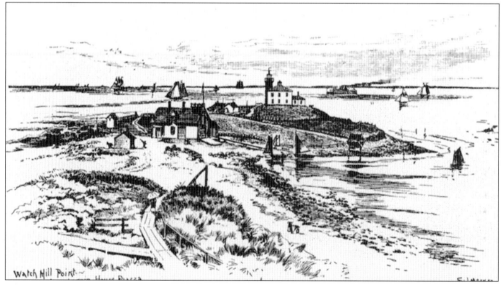

The Westerly Physicians Association reported an increase in medical fees in March 1915. The price of a house call was increased to $1.50 within a two-mile radius. Office calls remained at $1. It was claimed that the physicians in this locality had been working under the same rate that was inaugurated in 1870.

Three

CHURCHES AND SCHOOLS

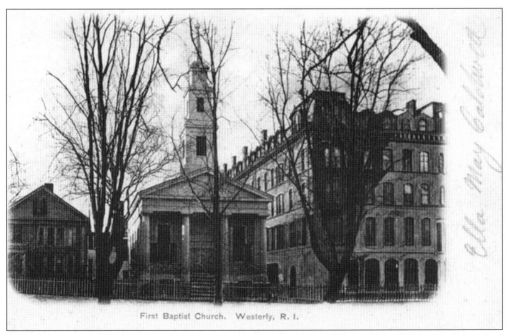

A new organ was purchased in January 1915 to take the place of the one that had served the First Baptist Church for more than 50 years. The new organ was built by the Estey Organ Company of Brattleboro, Vermont, and was reported to be the most modern instrument in Westerly at that time. The organ operated by compressed air through brass tubes.

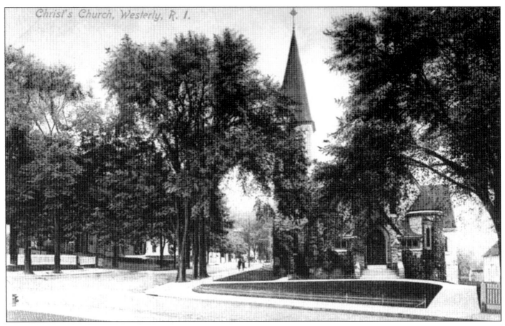

A commemorative service of the Christ Episcopal Church of Westerly was held at the end of October 1909 to celebrate its 75th anniversary. An address was given by Rev. W. F. Williams of the church's early years. He also spoke of the old union meetinghouse being the cradle where many congregations of Westerly were nurtured until the numbers of parishioners had increased and they were able to stand alone.

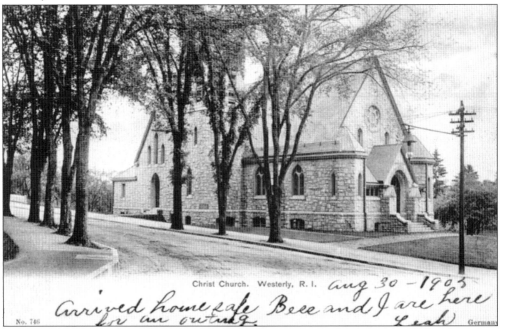

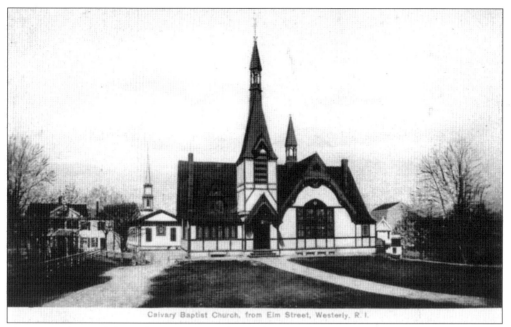

Many members of the Calvary Baptist Church heard a festive program of recitations, songs, and instrumental selections in December 1914. A large Christmas tree was decorated, while sandwiches, cake, and ice cream were served to all those present.

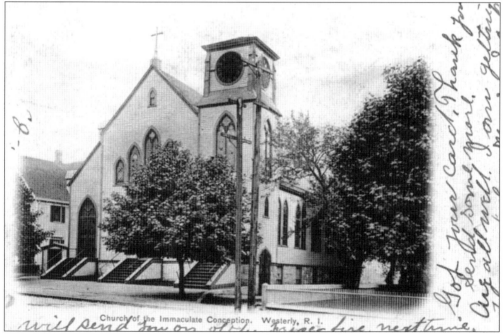

The annual fair of the Church of the Immaculate Conception was held on August 1, 1911, at Villa Marie, near Thompson's Cove. The spot was reported to be ideal for an outdoor fair and lawn festival because it overlooked the Pawcatuck River and was close to the trolley. The grounds at Villa Marie were brilliantly lighted with over 200 incandescent lights, and the drive was lined with Japanese lanterns. It was said to be beautiful.

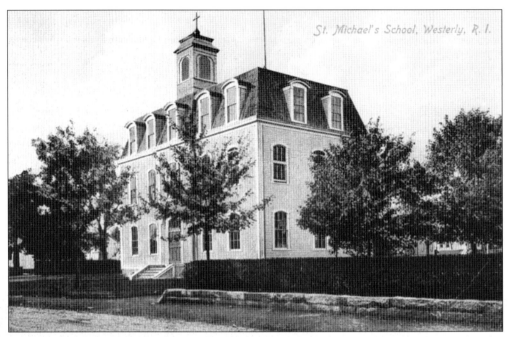

In May 1911, preparations were being made at St. Michael's Church and School for the church's 50th anniversary. The church had about 100 members in 1860 and had grown to over 4,000 some 50 years later. The pastors of the church were men earnest in their work who had the uplifting of their people at heart.

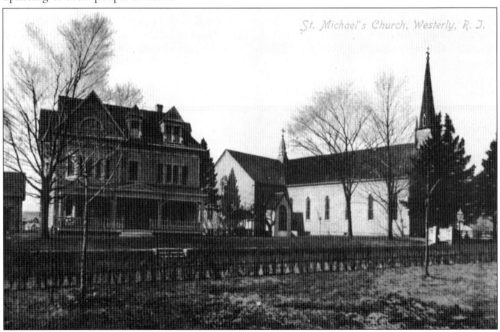

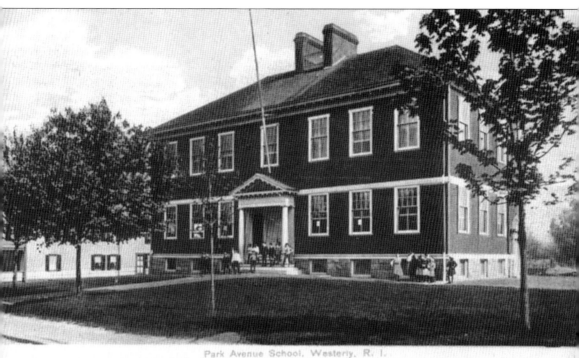

Park Avenue School, Westerly, R. I.

Westerly was the first in the state to teach agriculture in its schools. Implemented in 1913, experimental gardens were created by students, under the direction of professors of the state college. The program was hoped to be a beginning of a movement that would result in redeeming some of the thousands of acres of unproductive land of western Rhode Island.

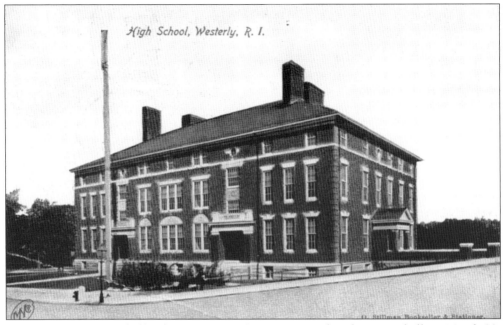

At a special meeting of School District No. 1's taxpayers at the Elm Street hall on March 28, 1901, $50,000 was appropriated for the purpose of constructing a new high school building. The new building was fitted with all the modern school conveniences, including liberal seating for classrooms and the largest school desk made, the lid-top desk.

Thomas Fitzpatrick of Willimantic, Connecticut, known as "Steeple Tom," returned to Westerly in June 1915 to work. He had just returned from repairing the twin spires of the Cathedral of St. John the Baptist Church in Savannah, Georgia. Years prior, "Steeple Tom," with his partner "Steeple Joe," had painted the spire of the Seventh-day Baptist Church.

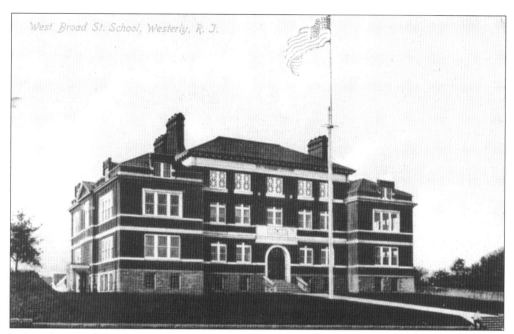

In March 1899, the ground was broken for the construction of the West Broad Street School, one of the most modern school buildings of its time with up-to-date heating, lighting, plumbing, and ventilation systems. The foundation was made of red Westerly granite.

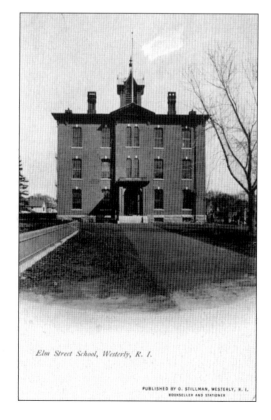

An open house to display the work of pupils was held at the Elm Street School in June 1911. Samples of cooking, baking, and sawing were displayed. In the manual training department, the boys had 60 pieces of furniture on display that had been made during the year.

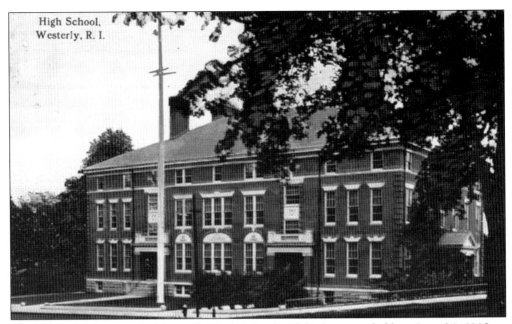

The graduation exercises of Westerly High School's 29th class were held on June 26, 1902, at the Bliven's Opera House. The stage and hall were well decorated by the incoming senior class and were very pleasing to the eye. Arthur Roche, the salutatorian, delivered an oration on the source of our country's prosperity.

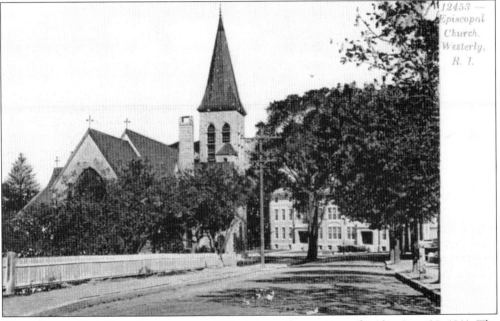

There was considerable excitement around Westerly on the morning of Friday, June 30, 1911. The first flying machine ever seen was reported. Looking heavenward, those fortunate enough to see it reported that the airship sailed through space in the direction of New London, Connecticut. Many in the center of town saw the machine and rushed to the roofs of the business blocks. Many farmers on the outskirts reported frightened cattle and sheep.

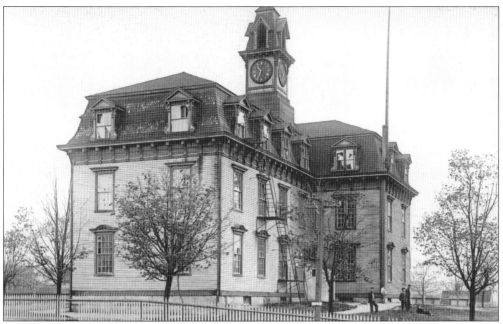

The Palmer Street School was built around 1876 and had a beautiful clock tower atop the building. The clock was an excellent timepiece and was always kept in good order. In 1900, the building's use as a school ended when the West Broad Street School was built and occupied. The building was sold to the Lorraine Manufacturing Company, which had a large mill nearby. (WHS.)

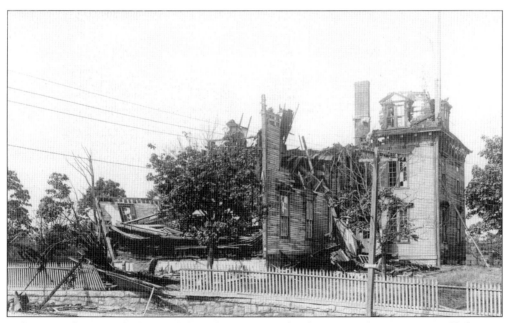

A disastrous fire severely damaged the Palmer Street School on September 22, 1911, and left many who had fond memories of it with a heavy heart. The fire was first seen in the lower hallway and quickly worked its way up the stairwell toward the tower. Within a short time, the tower fell down into a mass of flames, taking the heavy bell with it. (WHS.)

A very cold winter in 1906 was good news for the ice harvesters of the Westerly and Watch Hill Ice Company. The company supplied its customers with ice harvested from Wood River in Wood River Junction. Many purchased the junction ice, claiming it to be second to none in the state for pureness.

After the fire that destroyed the Palmer Street School, workmen from the Lorraine Manufacturing Company recovered the bell from the burnt wreckage. The bell, which was known to have an excellent tone, was given to the Congregational Church to replace the cracked bell that hung for years in the belfry and had a dissonant tone. However, upon the trial of the new bell it was found that the heat had destroyed its beautiful tone.

Four

Pawcatuck River

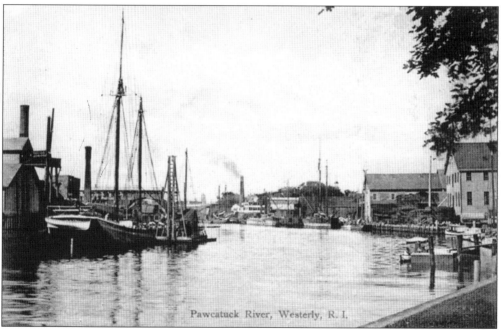

Many viewed the ship *Santa Maria* as she sailed up the Pawcatuck River. On October 1, 1915, the replica of Christopher Columbus's ship was on exhibit and drew a large crowd during her stay. The ship was an exact replica and included wax figures, one of which represented Columbus. One interesting relic aboard was the anchor carried on the original ship, which had been recovered in 1891.

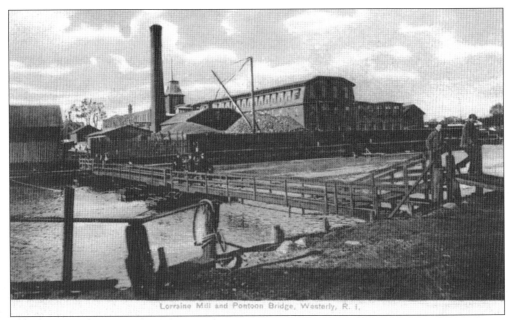

Lorraine Mill and Pontoon Bridge, Westerly, R. I.

In the year 1909, the United States War Department had given permission to C. B. Cottrell Sons and Company to construct a pontoon bridge over the Pawcatuck River. One condition was that a man always be in readiness to open the bridge when a vessel needed to pass. The bridge had been in place prior and was of great convenience to many who wished to cross the river below the Broad Street bridge.

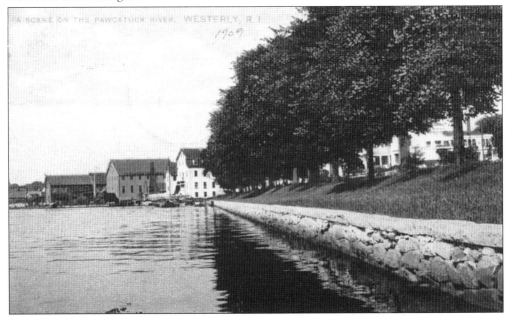

In 1910, a very cold January provided the area with the finest ice-skating conditions seen in years, even on the Pawcatuck River. It was reported that large parties were seen skating on the river just below Cottrell's shop out to the Clark Thread Mill. Beyond there, good skating conditions were found all the way to Pawcatuck Rock, and some skated the distance to Watch Hill on the smooth ice.

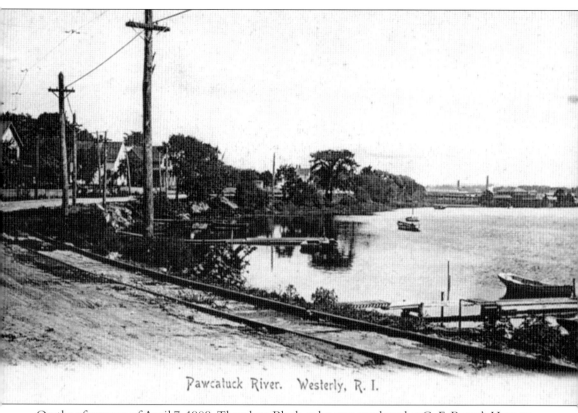

Pawcatuck River. Westerly, R. I.

On the afternoon of April 7, 1909, Theodore Black, who was employed at C. F. Berry's Harness Shop on High Street, glanced out the shop window and saw a horse standing in the muddy river. Seeing that the horse was stuck in the mud, Black waded in and freed the horse, which had wandered down to the river for a cool drink.

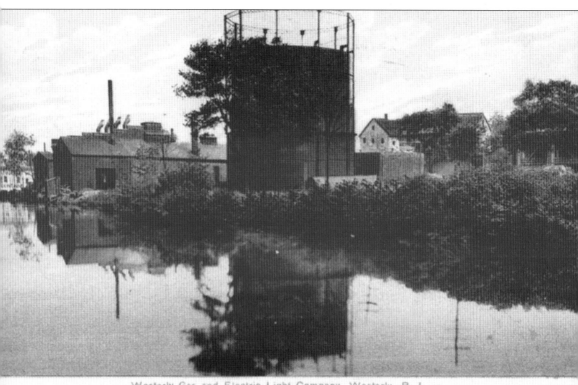
Westerly Gas and Electric Light Company, Westerly, R. I.

Westerly Gas and Electric Light Company on Canal Street made improvements at the plant in April 1904 when a new and larger up-to-date generator and new boiler were put in place. In addition, many of the streets were torn up for the installation of new and larger pipes to facilitate the dissemination of gas in the business portion of the town.

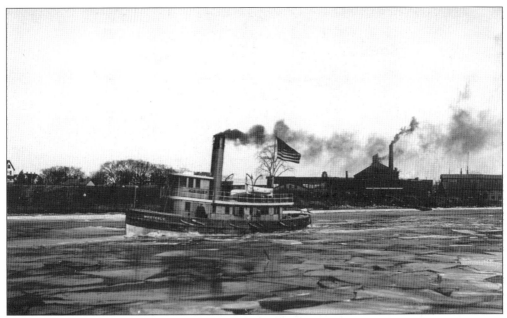

On a Sunday morning in January 1910, the tug *Westerly*, while breaking ice down the Pawcatuck River, had a bad leak in the hull, forcing the captain to beach her. The large hole below the waterline was covered with a board and a bed quilt, and the tug was again floated. Brought upriver to Sherman's Wharf for proper repairs, the little icebreaker was soon on the job again. (WHS.)

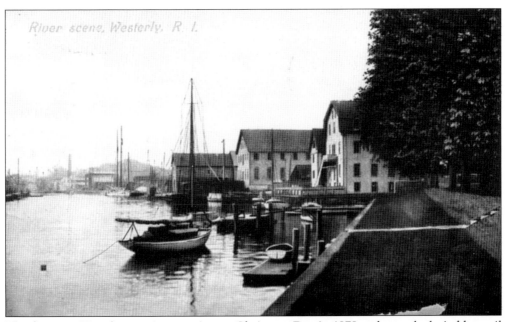

The first tug *Westerly* came into service on Christmas Day in 1879 and served admirably until it was replaced by a newer, more powerful tug in 1912. The new tug *Westerly* was built by J. S. Ellis and Son at Tottenville, New York. She was 75 feet in length and heavily timbered and braced. Her first run to Stonington, Connecticut, was on March 23, 1912, and the new *Westerly* steamed well, steered beautifully, and her engines gave no trouble whatsoever.

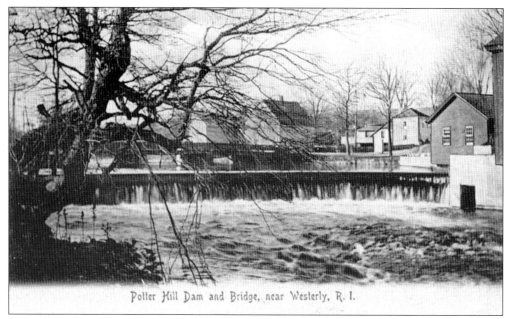

Potter Hill Dam and Bridge, near Westerly, R. I.

High water from heavy rains and melting snow in late February 1903 was too much for the dam at Potter Hill. A heavy volume of water had been pouring over the dam for quite sometime, and when the dam went down, the water above the dam fell rapidly, while the water level below rose quickly. The people downstream were notified of the coming danger.

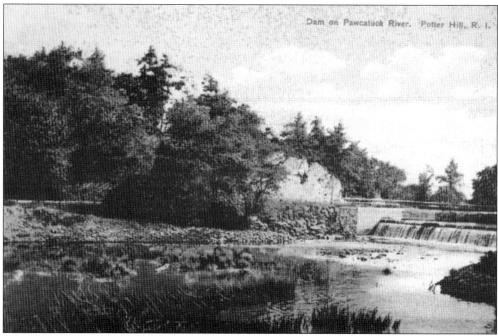

Dam on Pawcatuck River, Potter Hill, R. I.

The river below the Pawcatuck Dam was cleared of the wash and growth in September 1910. The accumulation of mud and boulders had built up, and dredging the channel to make it deeper and wider was of vital importance to the conservation of the river. The work was done when the mill at Potter Hill was not running.

Hopkinton Bridge, Near Westerly, R. I.

On June 21, 1908, at 1:20 a.m., the people of Westerly and all of the villages within a radius of 12 miles from Brightman Hill in Hopkinton were awakened by a thunderous bang so loud that it shook the windows and rattled the dishes in many homes. The mysterious noise was not learned of until the next morning when word came from Hopkinton that 1,000 pounds of dynamite, which was stored at Brightman, had exploded. The dynamite was being used by John Bristow, who had the contract for macadamizing the road from Hopkinton City to Hope Valley. The building that stored the dynamite was about a quarter of a mile from the nearest home. However, in Canonchet a window in Lizzie Hoxsie's home had been blown in and other damage around the area was made known over time and blamed on the mighty blast from Brightman Hill.

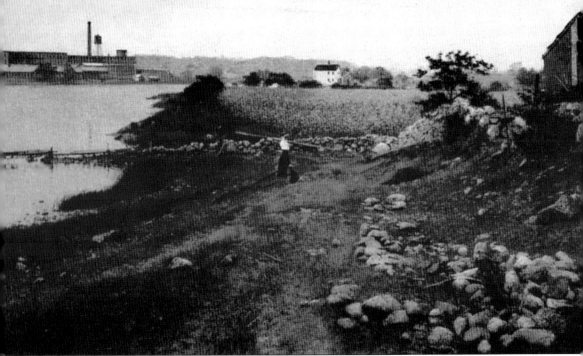

Burglars used nitroglycerine to blow open a large safe at the William Clark Company, a branch of the American Thread Company, on March 3, 1910. The night watchman heard no noise but discovered upon his rounds that the safe door was missing, and that it was blown completely off and found several feet away. Six horse blankets and some burglar tools were the only clues left behind.

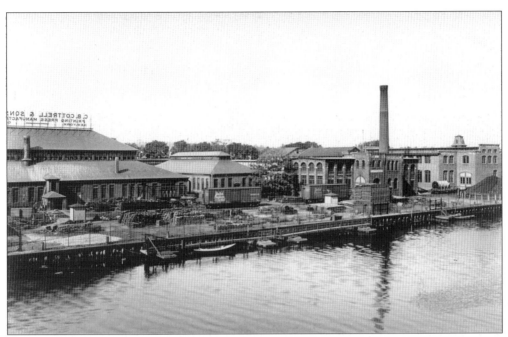

On March 23, 1910, the schooner *J. S. Terry*, loaded with 200 tons of granite paving blocks, was taken down the river bound for Brooklyn, New York. The tug *Westerly* also took the schooner *Grave P. Willard* down the river for a load of molding sand for Cottrell Printing Press Works. The tug then brought *Barge 714*, loaded with coal, upriver for unloading. This was just an average morning on the river in 1910. (WHS.)

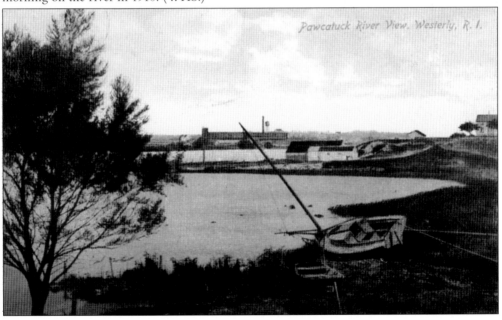

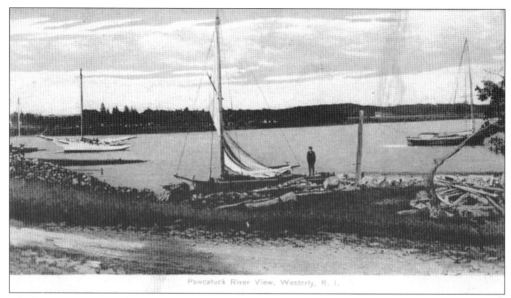

Pawcatuck River View, Westerly, R. I.

The building of vessels in the early days at scattered shipyards along the Pawcatuck River was a major employer in Westerly. Huge sticks of timber made of oak, chestnut, yellow pine, and other types of wood were procured and used in ship construction. Many separate trades and skills were used before a vessel was finished and could glide swiftly down the well-greased ways into the Pawcatuck River.

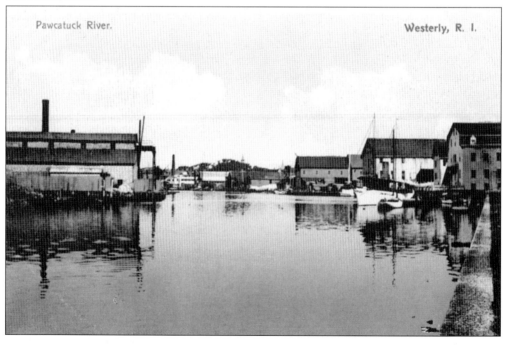

Pawcatuck River. Westerly, R. I.

Five

Transportation and Trade

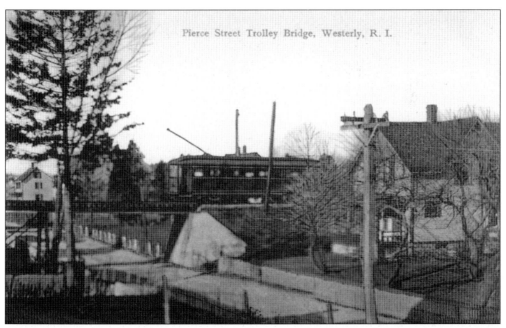

The first serious accident of the Pawcatuck Valley Street Railway occurred on August 7, 1899, when two trolley cars collided. The accident happened on Peleg Clark Hill. Car No. 3, while on its way to Watch Hill, collided with car No. 5, which was on its way to the Westerly Railroad Station. Several passengers were injured in the crash, and the two cars suffered damage to their front platforms.

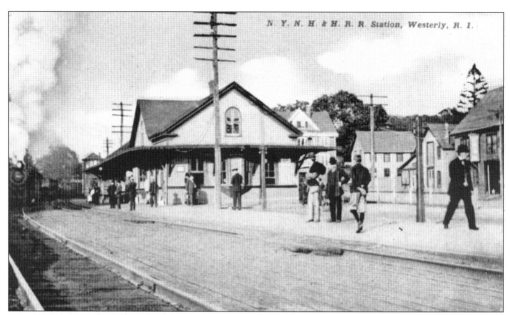

Thomas Sutcliffe met a peculiar experience on the evening of August 15, 1901. While standing on the platform of the Westerly Railroad Station, the express train rushed past, and he turned to keep the dust and cinders from his eyes. A mail pouch was thrown from the train, to his surprise, knocking him down. Uninjured, he exclaimed there should be a better way to receive the mail at the station.

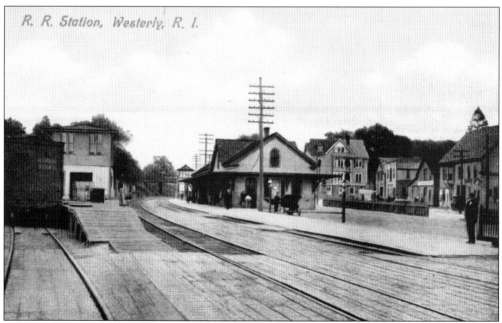

Everyone welcomed a visit to the Westerly Railroad Station on October 5, 1901, by the assistant superintendent Elwell of the Shoreline Division of the New York, New Hampshire, and Hartford Railroad. He came to inspect the crude lighting system at the station. Many complaints were heard about the dimness of the kerosene lights outside and the gas lights inside. Many hoped the reign of kerosene lamps at the station would soon be over.

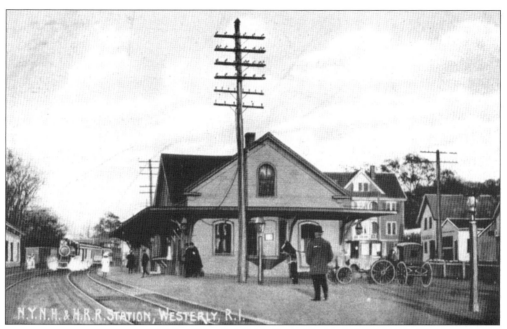

On August 12, 1903, H. R. Mitchell's gray horse was attached to a Westerly Furniture Company delivery wagon at the freight depot. Mitchell and P. H. Shea were loading bedsprings when one of them slipped and fell against the horse. The animal started on a run up the tracks, leaving a trail of bedsprings, and when she was stopped, the wagon was reportedly empty and quite badly smashed. (WHS.)

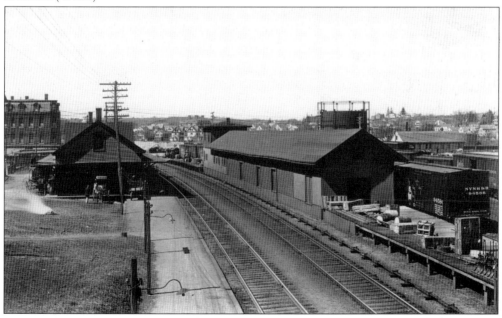

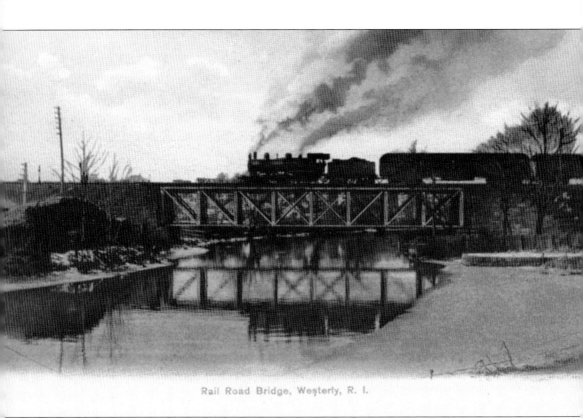

Rail Road Bridge, Westerly, R. I.

In the early days, painting the old iron railroad bridge was difficult and dangerous work. The removal of scale by scraping with iron brushes was the first step, and then it was necessary to apply two coats of paint or liquid asphaltum No. 46. In most cases, railroad companies used asphaltum rather than paint for its inherent properties, necessary for the protection of steel against corrosion.

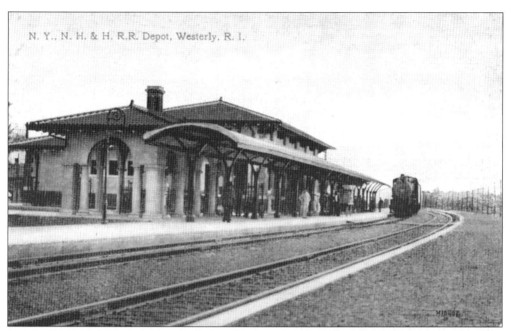

In July 1911, work begun on a new railroad station for Westerly. The architectural style of the new station was Spanish Renaissance. The walls were constructed of hollow terra-cotta blocks with plaster on the inside and plaster stucco on the exterior, and the roof was covered with red tile. The choice of fireproof materials was intended to improve safety at the station.

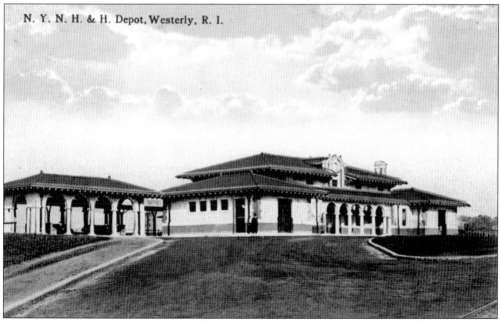

In April 1913, the new passenger station was open for business. The new structure, with its beautiful terra-cotta, was a place of grandeur in comparison to the old station. The New York, New Hampshire, and Hartford Railroad was very satisfied with the terra-cotta roofing that was installed on the stations in Cedar Hill, Rowayton, and Terryville in Connecticut, and in West Barnstable, Foxboro, and North Situate in Massachusetts.

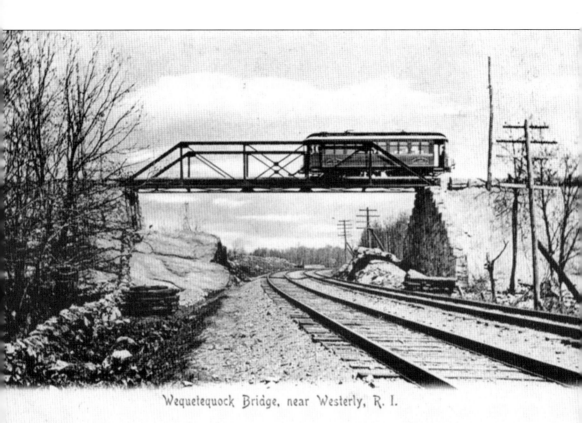

Wequetequock Bridge, near Westerly, R. I.

A trolley car jumped the tracks, en route from Weekapaug to Westerly on September 9, 1914. The car struck a combination pole, breaking it in two. Several electric lines came in contact with the tracks, causing an illumination with a display of pyrotechnics. A large crowd gathered to watch the bolts of electricity shoot in all directions, and the apples hanging from trees near the wires were burnt.

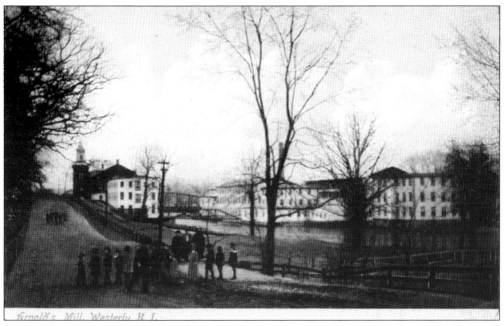
Arnold's Mill, Westerly, R.I.

On a cool evening in 1840, while on their way to work at a mill along the Pawcatuck River, girls witnessed a meteor shower. Never having seen such a sight, they arrived for work frightened, praying, and crying because they believed that the judgment day was at hand. Superintendent Newberry, with his dry humor, told them to go to work and said, "who ever heard of the judgment day coming at night!"

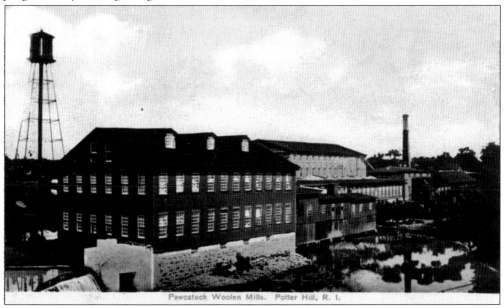
Pawcatuck Woolen Mills, Potter Hill, R.I.

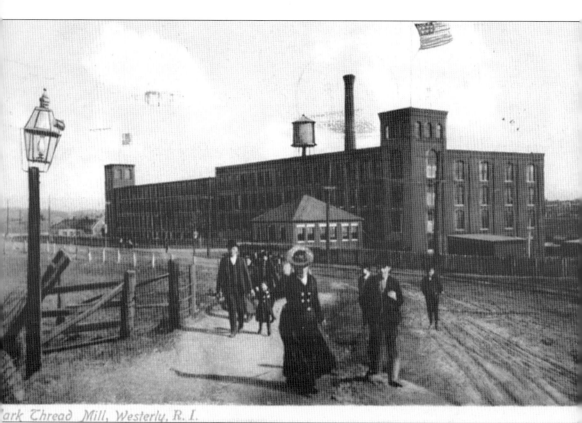

Clark Thread Mill, Westerly, R. I.

The American Thread Company finalized plans to double the size of the William Clark Plant in March 1899. When the plant was finished, it contained 54,000 spinning spindles, over 20,000 twisting spindles with necessary finishing machines, and employment for an additional 300 to 350 extra hands. The plant manufactured the finest grades of yarn, thread, crocheting thread, and silk.

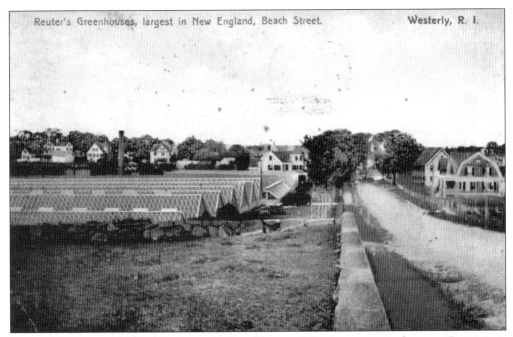

An explosion on April 2, 1899, startled residents of the lower part of town. Carpenters working on S. J. Reuter's new greenhouse were thrown from their feet, but not injured, when a cast-iron, 50-horsepower boiler exploded. The building that housed the boiler was a total wreck. The blast also shattered hundreds of panes of glass, depriving thousands of roses and carnations of proper cover.

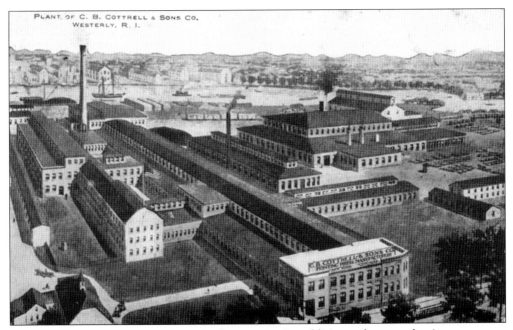

Plans were finalized in November 1899 for an extensive addition and many other improvements to the C. B. Cottrell and Sons plant. When completed, the plant became the second largest of any pressworks in this county. The largest was R. Hoe and Company.

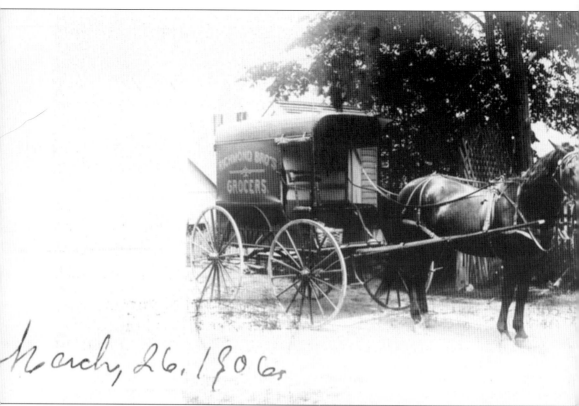

Heavy rain in February 1904 caused flooding in many areas of Westerly and washed out many roads. Four inches of water covered the floor of the Richmond Brothers Grocery store on West Broad Street. The cleanup took several days, but then it was business as usual at the grocery store.

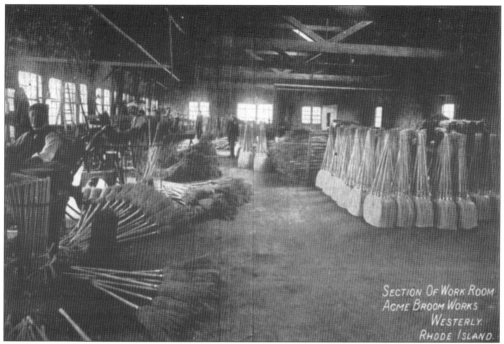

The Acme Broom Company came to Westerly from Newton Falls, Massachusetts, in November 1907. The company operated a broom factory in the old powerhouse on Coggswell Street. The old powerhouse building was then owned by Mystic Light and Power Company. The broom company was to originally be located on Margin Street, but the building there could not accommodate the machinery used in the manufacture of brooms.

The old adage "and the cat came back" is familiar to all but is seldom applicable to horses. However, a horse sold at auction at the Picard Stables in September 1915 was the exception. Sold to a farmer in Bradford, the horse left one night, walking about six miles to Railroad Avenue and into the barn of his former owner. The next day the horse was escorted back to Bradford.

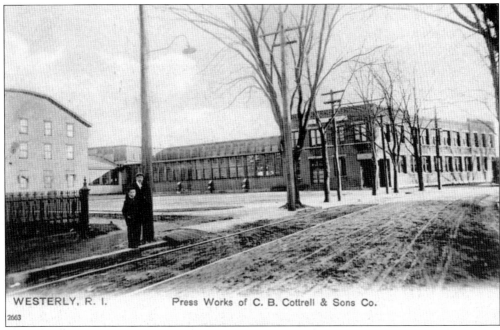

WESTERLY, R. I. Press Works of C. B. Cottrell & Sons Co.

In August 1910, one of the largest presses ever built at the pressworks of C. B. Cottrell and Sons was exhibited and attracted many from town who were interested in seeing the triple-decker do its work. The press had the capability to produce 9,000 magazines per hour that were 240 pages each. The press took about six months to build at a cost of about $50,000 and weighed 152,000 pounds. (WHS.)

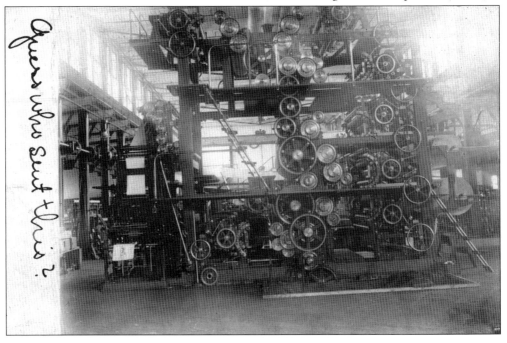

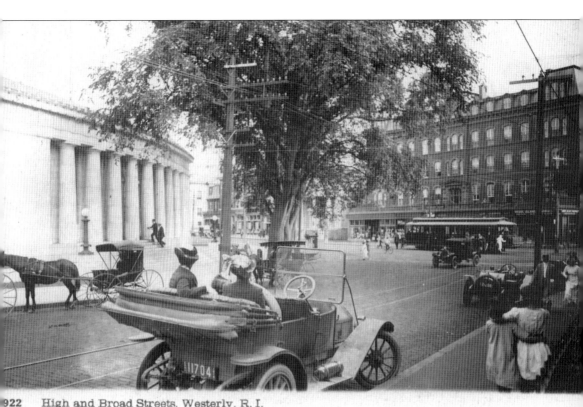

High and Broad Streets, Westerly, R. I.

The Rhode Island General Assembly passed an automobile law requiring that, as of June 1, 1904, all motorcars and motorcycles be registered in the office of the secretary of state and the machine must carry and prominently display the registration number. In addition, all machines must be locked when left standing on the highway to prevent them from "running away." (S. A.)

hite Rock Mill, near Westerly R. I.

A daring highway robbery occurred on April 22, 1913, on White Rock Road. Edward Sullivan, a representative of the Loose and Wiles Biscuit Company of Boston, was on his way to White Rock in a buggy when two men ran out from the woods with revolvers demanding Sullivan's satchel. Sullivan offered no resistance and handed his satchel to the highwaymen who retreated toward the Pawcatuck River where they got into a boat and crossed the river. Sullivan drove to the White Rock Mill where he summoned the Westerly Police to report his sample biscuits being stolen at gun point. It was soon realized that the robbers thought that Sullivan was the paymaster at the mills and that the satchel contained about $4,600. Instead, the bounty they received was nothing more than sample biscuits. At the mill, Sullivan was heard to say he could not believe his biscuits would be so popular.

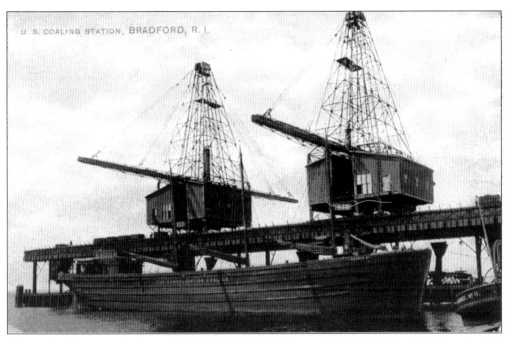

The tug *Mable S.* caught fire on March 8, 1899, while en route from New York to Westerly with two coal barges, the *Arthur* and the *Eddie*, in tow. The speaking tubes and the bells connecting the engine room were burned away, hindering the crew. The fire was contained, and the tug was quickly repaired. The cargo of coal was successfully delivered to the Pawcatuck Valley Street Railway and C. B. Cottrell and Sons.

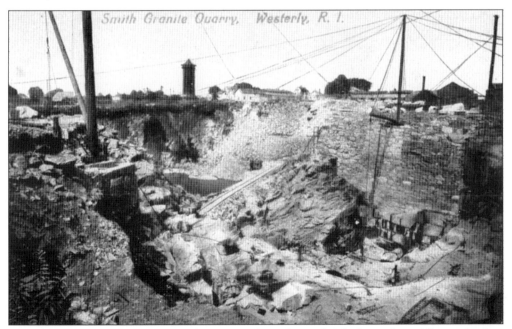

At Smith Granite Company in March 1903, work was being finished on a fine soldiers and sailors monument, which was to be 40 feet high. Many townspeople could not resist stopping by the Smith Granite Company to view the beautiful work in various stages of production.

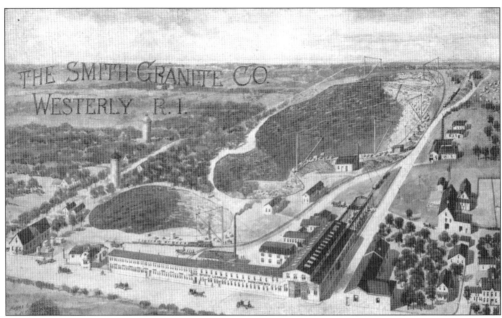

The Westerly Branch of the Granite Cutters National Union signed a new agreement with area granite manufactures in February 1903. The new contract was for a period of two years and called for an eight-hour workday. The new pay rate was 37.5¢ per hour for 75 percent of the employees, and the remaining cutters earned 35¢ per hour. Overtime paid 15¢ per hour extra. (WHS.)

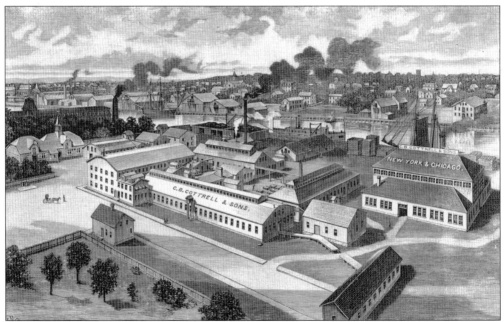

As the town grew, so did its local newspaper, and in 1897, the *Westerly Sun*, which is committed to providing its readers with a quality newspaper, placed an order with C. B. Cottrell and Sons Company for a new press. The name of the press was "web perfector," it weighed 10 tons and was impressive to watch because it had the ability to print on a continuous web of paper, which the press drew into itself from a large roll.

Six

WILCOX PARK

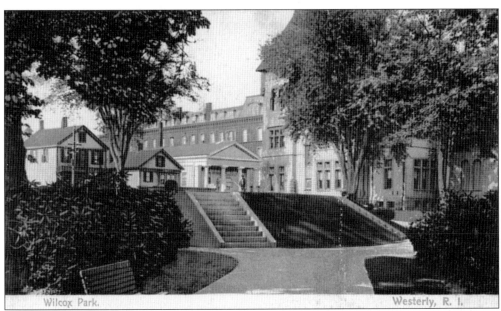

On April 3, 1899, the Memorial and Library Association sold the double wooden house at 50-52 Broad Street and its barns, outbuildings, and fences at public auction. In order to layout the new Wilcox Park, it was found necessary to remove them because they were on the property. The sale started at 9:00 a.m., and over 100 people gathered early to inspect the buildings offered for sale. All the property was sold without the underpinning or any of the stonework, and the condition of the sale provided for the removal of all the buildings from the premises inside of six weeks. The total receipts from the auction amounted to $291.50.

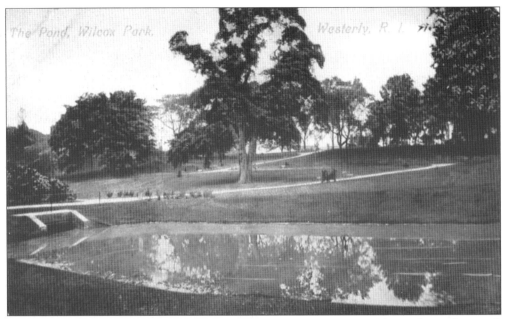

Anna Schultz and H. Russell Burdick took an unexpected dip in the muddy pond in Wilcox Park on February 3, 1915. They started out on their sled at Lemon Hill at the north side of the park heading toward the memorial building but, to their misfortune, could not make a wide enough turn to avoid the pond. The two young people arose from the pond wet, but luckily uninjured.

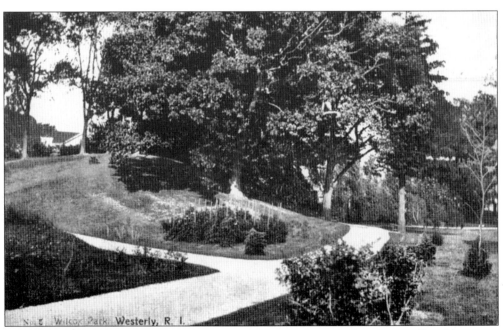

In December 1902, gutters were installed along the path in the park to carry off surface water, which prior to this had flowed down the middle of the walks washing them away in many places. The south pond was also cleaned and about 100 loads of sand removed.

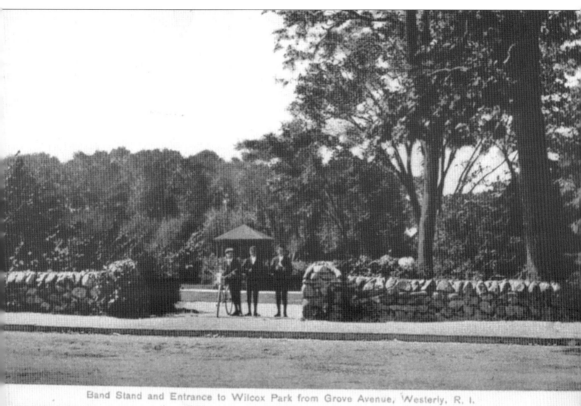

Band Stand and Entrance to Wilcox Park from Grove Avenue, Westerly, R. I.

The first band concert in June 1912 was a grand success, and the high school boys did a great job in their fund-raising efforts. They met in front of the memorial building and were given white collection boxes and sent to various entrances in the park. However, a number of boys refused to take the box marked 13, thinking that ill fortune would follow them with that number. Raymond Gavitt was not at all skeptical and carried the box marked 13 to the front entrance and stood vigil over it. The results of his work showed, because when counted, the box marked 13 contained the largest amount of money collected that evening.

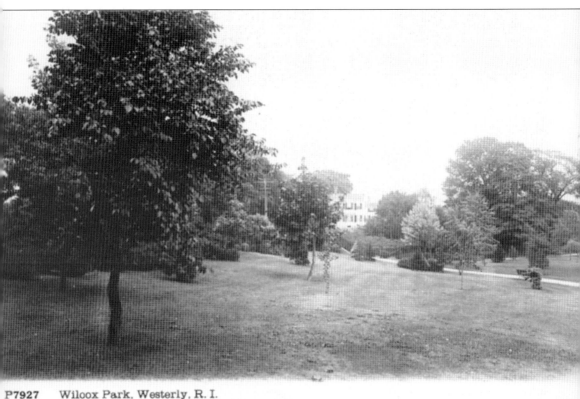

P7927 Wilcox Park, Westerly, R. I.

In November 1906, a long-desired addition to Wilcox Park became a reality when a parcel of land from High Street and Grove Street was added and opened to the public. The trustees of the park purchased the land from the estate of Hannah B. Brown and immediately began plans for its improvement.

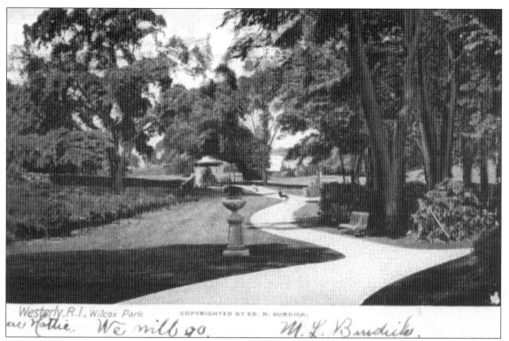

At Wilcox Park in the spring of 1907, work progressed on the opening of the Brown land, which had been purchased by the trustees of the park. The removal of the old stone wall, which ran between the two parcels, was accomplished. Many from town came to admire the new vista and openness created in the park.

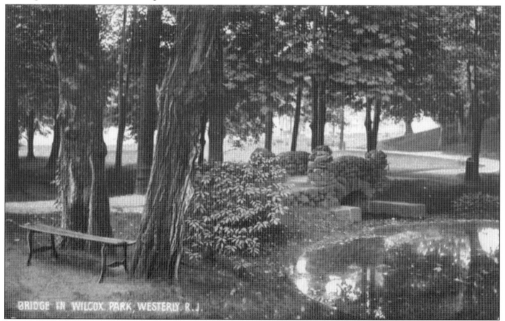

Many fully grown trees were transported to Wilcox Park in the spring of 1907. A good-sized Japanese palm was planted, as was a fine sycamore maple donated by Mrs. E. Clark Saunders of Granite Street. Magnolia trees removed from the High Street side of the Brown land and replanted were reported to have taken root after their short journey.

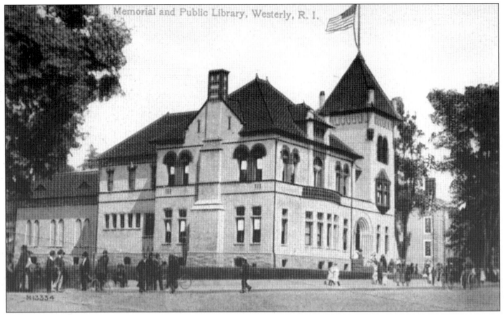

In November 1913, at the child welfare conference held at the public library in Providence, a large chart was on display showing the circulation, volumes, and expenditures per capita of the people in their towns. The figures showed that Westerly had a sizable reading community, ranking high on the charts. This was contributed to the excellent facilities in the town.

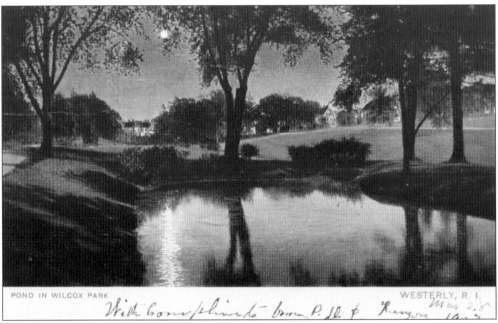

It was estimated that over 300 people, both young and old, were enjoying the wonderful skating and sledding conditions at Wilcox Park on the evening of February 3, 1915. They came with their skates, sleds, and most anything that would take them over the snow. It was said that the skating and sledding was never as good as it was that evening at Wilcox Park.

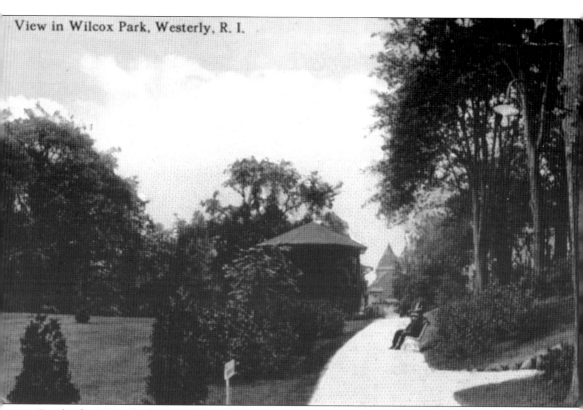

View in Wilcox Park, Westerly, R. I.

On the first Tuesday in June 1911, the townspeople gathered for the first band concert of the year. The contribution from the community was generous, and nearly $200 was raised to cover expenses.

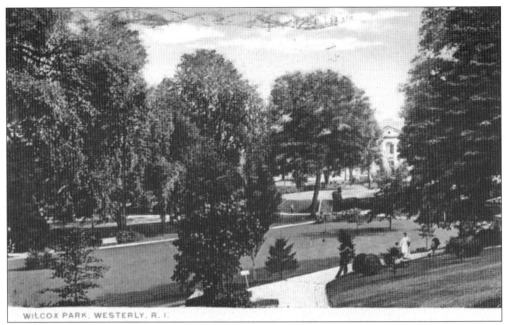

Hundreds gathered in Wilcox Park on Wednesday, December 24, 1913, as some listened and others sang songs appropriate for the Christmas season. Many came together in the park, not only those residing in Westerly, but many from the surrounding villages, to celebrate and share the joy of Christmas with others.

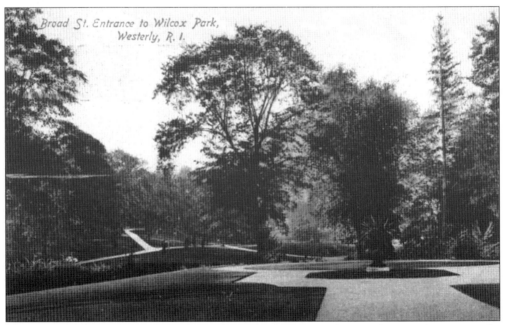

The first municipal Christmas tree was put up in Wilcox Park in mid-December 1913. The tree was beautifully illuminated for the occasion, having been tastefully strung with variegated lights. It was situated in the northeast corner of the park, a location that could not have been better chosen.

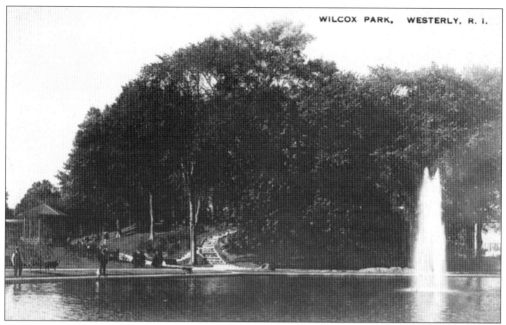

In the summer of 1911, an attempt was made to stop water from leaking out of the pond at Wilcox Park. The water level was lowered so that workers could place strips of broken stone and cement along the bottom of the retaining wall in an attempt to put a stop to the water's escape.

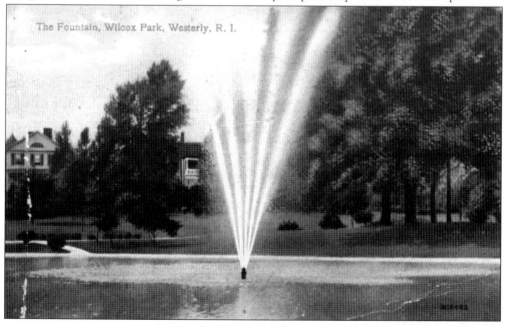

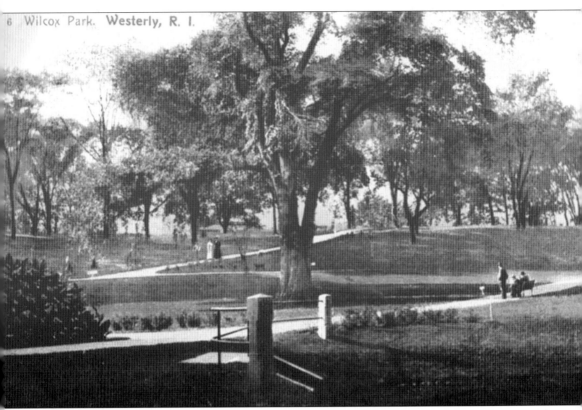

In June 1911, workmen from the Providence Forestry Company placed iron bolts into some of the large branches of the trees to prevent splitting. On one large ash tree, having five trunks from one butt, the men put a heavy iron ring around it to strengthen the tree.

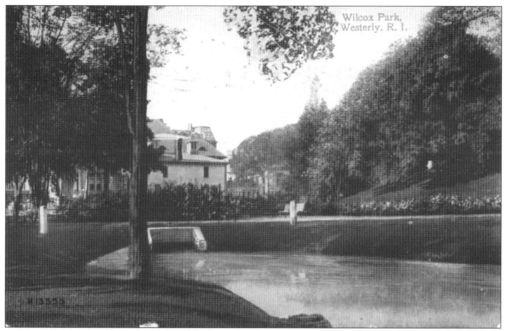

The Wilcox Memorial Library building on Broad Street was broken into on October 16, 1910. A small amount of money was taken from the librarian's desk, which had been pried open. Police chief Bransfield was notified and began working on the case.

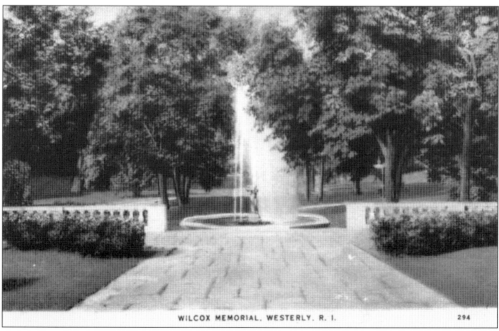

A carload of shrubbery arrived from the Andorra Nurseries of Philadelphia in October 1911 and was set out in the new section of Wilcox Park. Many from town stopped to admire the varieties of shrubbery placed about.

Much landscaping work was done on the new section of Wilcox Park in 1907. The work was done under the direction of planters employed by Frank Hamilton of Brooklyn, the landscape gardener who laid out the new park.

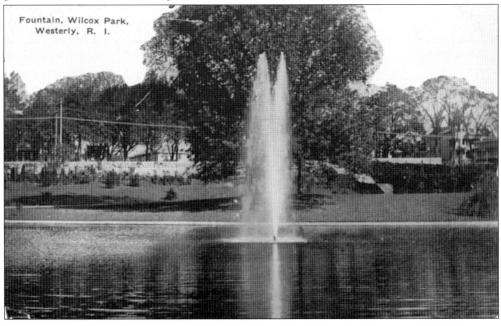

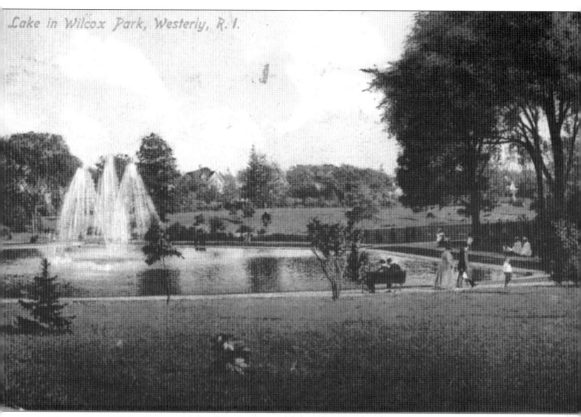

In November 1911, clay was laid in the bottom of the artificial pond and was ready for flooding. In the spring, a layer of loam was laid when the water was let off.

At the annual meeting and banquet of the Association of Westerly Physicians held in February 1910, the doctors and the people of Westerly were surprised. Dr. John Champlin announced he had equipped a private hospital for the use of the people of Westerly. Located in the center of town and having a gracious view of Wilcox Park, this new hospital was to be known as the Westerly Sanitarium.

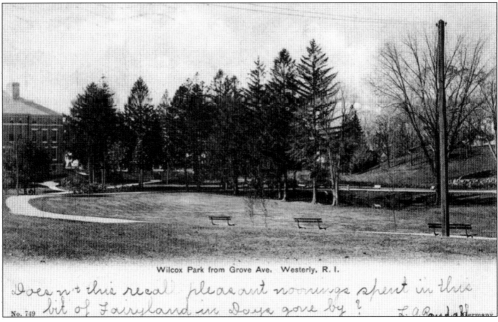

Ice-skating was an extremely popular pastime for the young people of Westerly. Many trudged either to Burden's Pond, Vose's Pond on Oak Street, the old canal bed, or Blackbirds' Pond near River Bend Cemetery. Also popular was the School-House Pond just off Union Street, known to many early inhabitants as Bull Frog Lake or Musk-Rat Retreat. There, for generations, young villagers waded for frogs, sailed their shingle boats, and skated time away.

Seven

Times to Remember

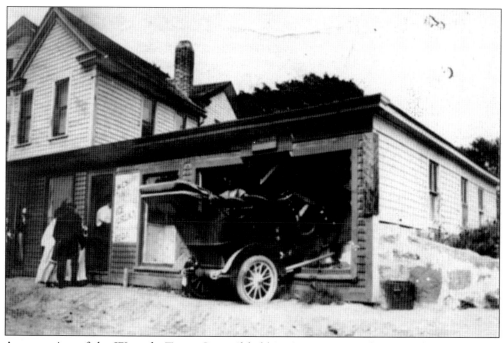

At a meeting of the Westerly Town Council held in August 1902, the council addressed the problem of motorized machines running through town at high speeds. After considerable discussion, an ordinance was passed regulating the speed in the villages at eight miles per hour with a penalty affixed for violation. For the first offense, the penalty was a $20 fine, and for each subsequent offense there was an added penalty of 10 days in the county jail.

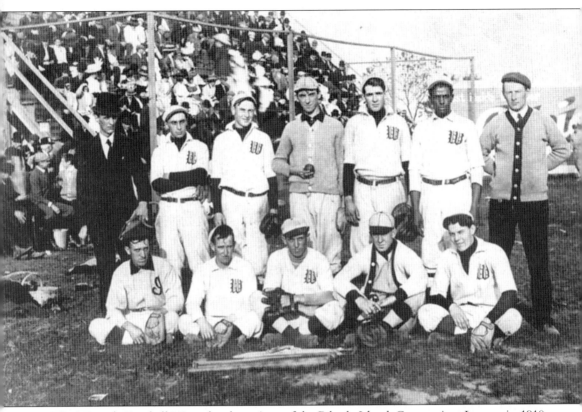

The Westerly Baseball Nine, the champions of the Rhode Island-Connecticut League in 1910, took time for the camera. They then raised their pennant before 2,000 cheering fans.

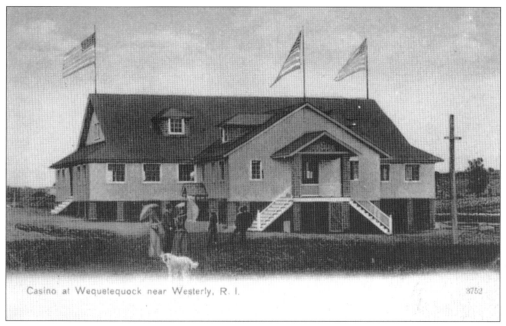

As reported in the local paper in May 1909, the Wequetequock Casino opened the season with large crowds. Many visitors came by trolley and found everything in fine shape and ready for the coming season. The orchestra played fine music while all in attendance enjoyed themselves.

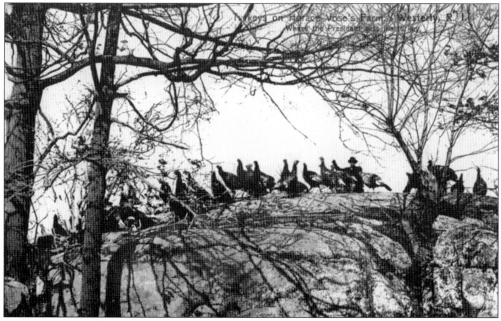

Horace Vose of Railroad Avenue was a prominent turkey man in Rhode Island. It became customary for Vose to provide the White House with a Thanksgiving turkey. In mid-November 1907, Vose selected two handsome 35-pound birds for shipment to the White House for Pres. Theodore Roosevelt to enjoy.

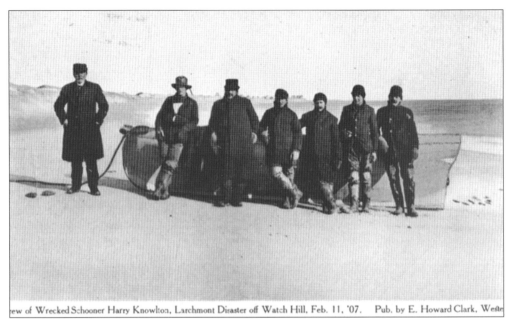

ew of Wrecked Schooner Harry Knowlton, Larchmont Disaster off Watch Hill, Feb. 11, '07. Pub. by E. Howard Clark, Weste

The schooner *Harry Knowlton* floundered after the collision with the *Larchmont* and then floated ashore at Quonocotaug. The heavy seas and rolling surf pounded the hull, and the *Harry Knowlton* broke up and quickly became a total wreck. The coastline became strewn with wreckage as the vessel's constant rocking on the sandy bottom released wreckage with every wave that struck the hull. The vessel was worth about $40,000 prior to the collision but only carried $18,000 worth of insurance.

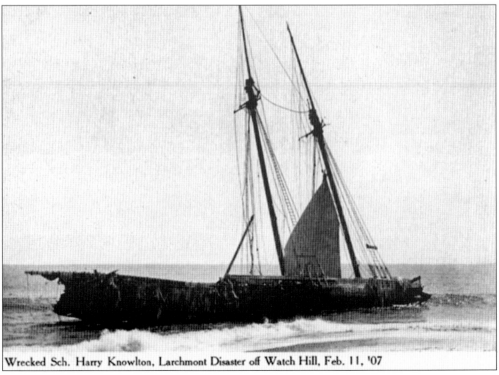

Wrecked Sch. Harry Knowlton, Larchmont Disaster off Watch Hill, Feb. 11, '07

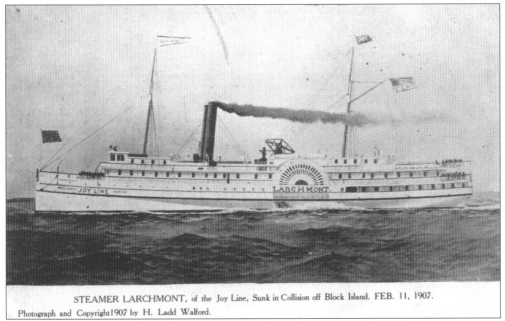

STEAMER LARCHMONT, of the Joy Line, Sunk in Collision off Block Island. FEB. 11, 1907.
Photograph and Copyright 1907 by H. Ladd Walford.

Rarely equaled in New England, a disaster off Watch Hill water occurred at about 10:40 p.m. on February 11, 1907, claiming over 130 lives. The steamer *Larchmont* of the Joy Line Steamship Company was en route to New York when she collided with the schooner *Harry Knowlton*. The steamer sank in 12 minutes. (WHS.)

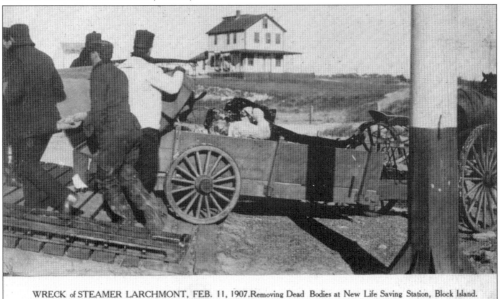

WRECK of STEAMER LARCHMONT, FEB. 11, 1907. Removing Dead Bodies at New Life Saving Station, Block Island.
Photograph and Copyright 1907 by H. Ladd Walford.

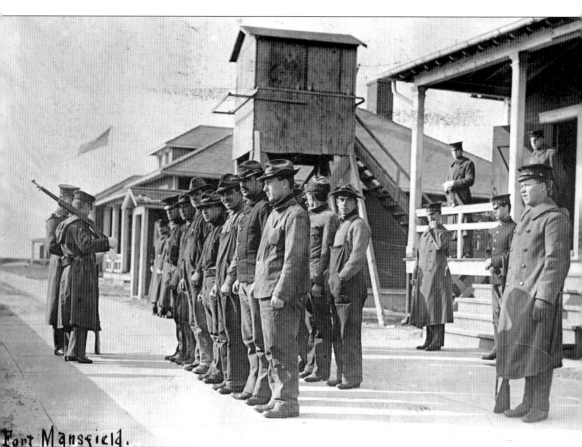

On October 6, 1913, troops from the 2nd, 12th, 131st, 132nd, 134th, and 146th Companies of Fort Wright, New York, and the 43rd, 88th, 100th, 125th, 133rd, and 157th of Fort Terry, New York, headed by the 11th Regimental Band marched down Granite Street into Dixon House Square. The troops were on their way to Fort Mansfield. Hundreds of people gathered along the street to admire the soldiers as they marched through town. (WHS.)

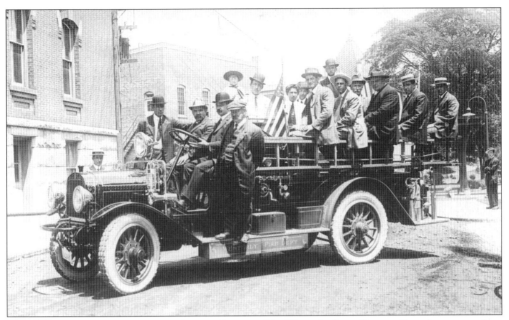

On April 14, 1914, an up-to-date fire truck arrived in Westerly from Boston for a demonstration. The 30-horsepower truck equipped with ladders, extinguishers, and all the equipment necessary to fight fires drew favorable comments after the demonstration. The truck was also capable of carrying between 15 and 20 men to and from a fire. (WHS.)

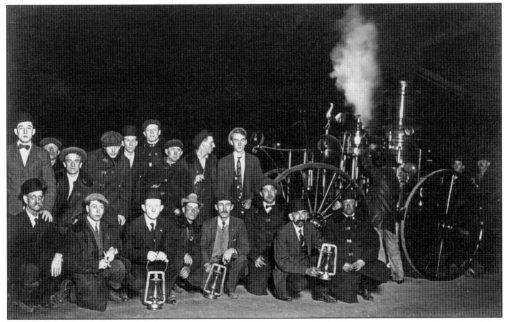

The Cyclone Engine Company No. 2 was called upon to fight fires at a moment's notice. The fire apparatus used by the company was a steam-powered pump or steamer cyclone, which was built in Pawtucket by a Mr. Cole. On occasion the machine would need service, and Cole would be summoned to perform the required fix. (WHS.)

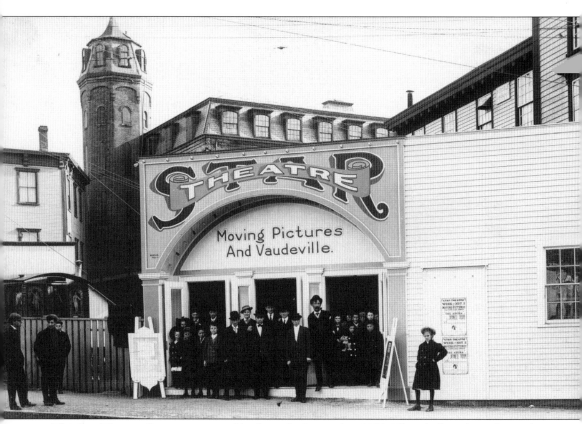

The Star Theater Company opened its doors in September 1908. The playhouse was located in the Old Seventh Day Mill on West Broad Street. The entrance was through a small building on the north side of the mill. (WHS.)

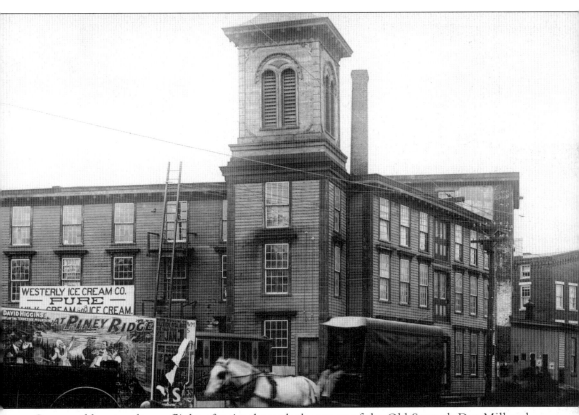
One would proceed up a flight of stairs through the tower of the Old Seventh Day Mill and enter the theater on the second floor. (WHS.)

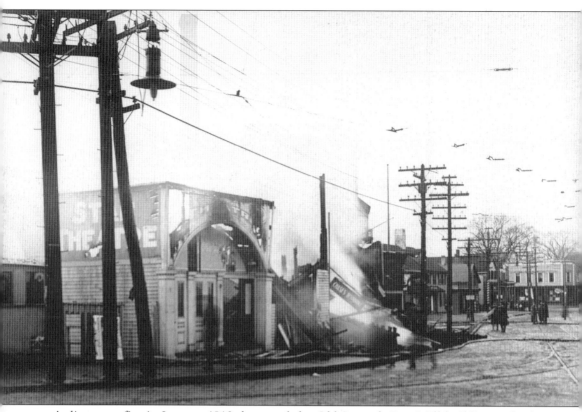
A disastrous fire in January 1913 destroyed the Old Seventh Day Mill building and other structures, leaving many businesses in ruins. The Star Theater and the Old Maxson Saw Mill were also destroyed. (WHS.)

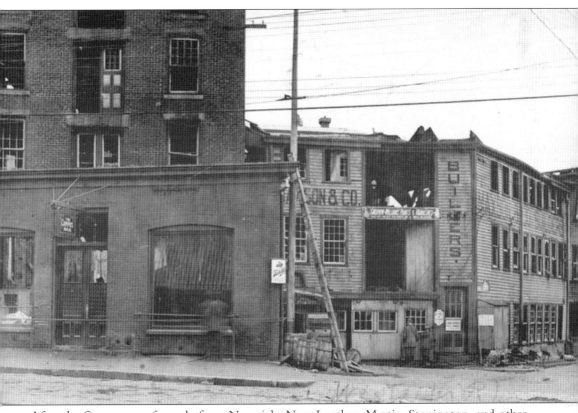

After the fire, scores of people from Norwich, New London, Mystic, Stonington, and other surrounding towns and villages came to Westerly to view the remains and twisted landscape of this well-known spot.

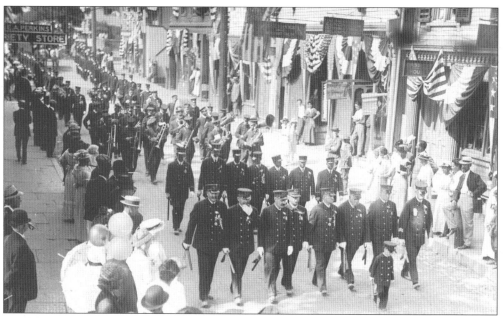

With a clear sky and a cool breeze, many gathered to view the street parade that was held each year in Westerly. Police officers and firemen from Westerly and other parts of the state marched through Westerly's gaily decorated streets. These gallant men, who were held in high regard, brought enjoyment to the spectators as they march honorably by. (WHS.)

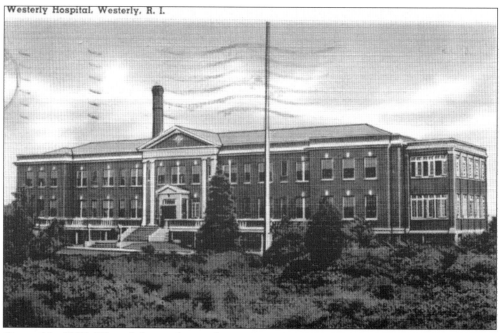

Opened in 1925, Westerly's new hospital was modern, providing its patients with up-to-date medical treatment. Prior to this, many in need of medical treatment would have to go upstate or to the Westerly Sanatorium, which reportedly had one of the finest operating rooms in the state.

Pleasant Street School, Westerly, R. I.

The Westerly Business College held a reception on February 15, 1899, to celebrate its first anniversary. The gathering was held in the college rooms located in the Wells Block on Broad Street. Well over 150 people were in attendance that evening due to the perfect weather. Also, the orchestra was well received.

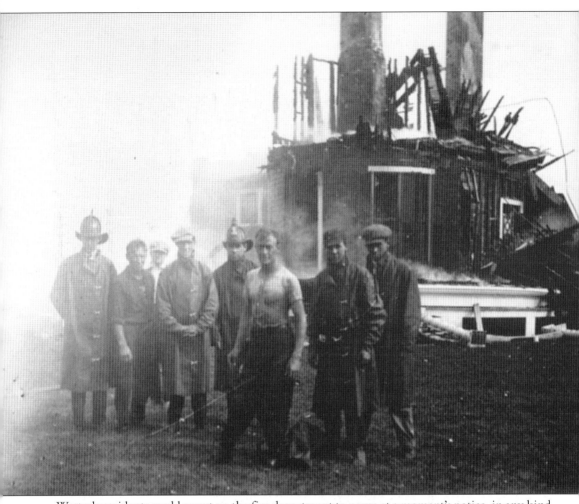
Westerly residents could count on the fire department to come at a moment's notice, in any kind of weather. A house fire such as this in Watch Hill was always difficult.

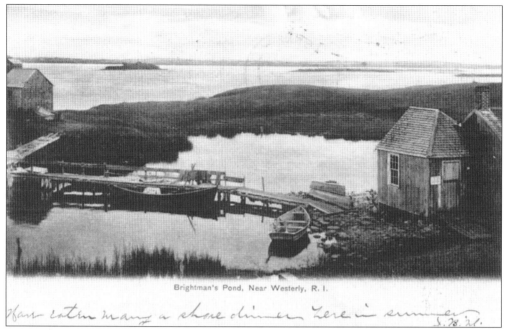

Brightman's Pond, Near Westerly, R.I.

The 50th anniversary of the securing of a charter by the Westerly Band was observed on August 28, 1913, with a reunion, clambake, and jollification at Barns Point, Brightmans.

An officer, while making his rounds in town on August 13, 1902, had an interesting experience. While stopping to light the gas lantern near the Niantic Bank, he heard a noise across the street. Upon investigating, he found a man asleep upon a branch high in a tree. When told to come down, the man refused. After several commands, the man came off his perch and by agreement started for his home in Watch Hill.

On March 13, 1913, at a gathering at the high school, the Westerly Boy Scouts were officially organized. Sen. Louis Arnold presided at the enthusiastic meeting with about 130 boys present. Addresses were given by chief scout Hon. Harry Cutler and Capt. E. R. Barker. Following the talk, the oath of allegiance was administered to the boys wishing to join.

The harvesting of ice by the local icemen normally began in mid-January of each year and continued until the large icehouses used to store the ice were filled. At the L. D. Richmond plant, 50 men were put to work plowing, sawing, spading, and packing the ice for summer use. About 40 cakes of ice were processed each minute, with an average of 2,000 tons each day. Hay and straw were used to cover the ice until it could be used.

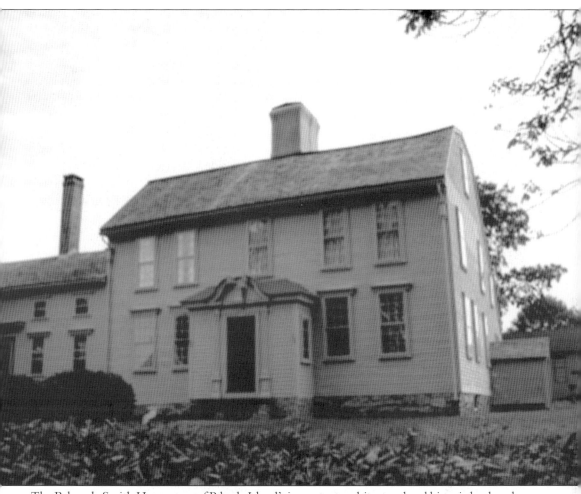

The Babcock-Smith House, one of Rhode Island's important architectural and historic landmarks, is an enduring connection to Westerly's past. The Babcock-Smith House Museum is a marvelous educational experience for all who visit.

Pictured here is Ed Carroll, past Westerly Historical Society president, now deceased. He was much loved by his family and friends. His dedication and contributions to the preservation of Westerly's historic past are appreciated, and he will be sadly missed.

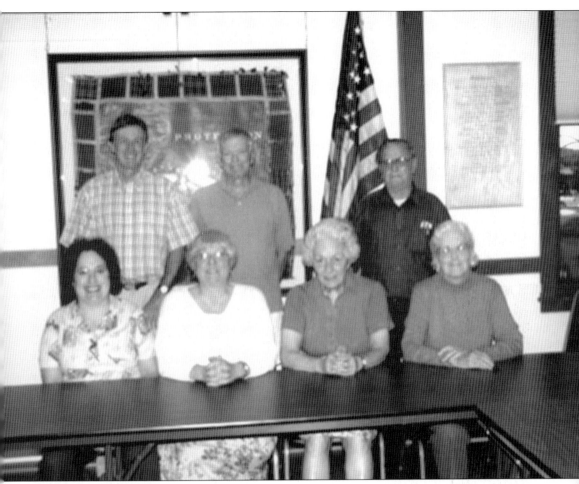

Shown here are the Westerly Historical Society officers. From left to right are (first row) Lise Mayers, Susan Cline, Anne White, and Elizabeth Driscoll; (second row) Thomas Wright (president), Bob Benson, and Dwight Brown. The first meeting and formation of the Westerly Historical Society was held on January 21, 1913, at the Memorial Building. The society from that time to the present has done a wonderful job in preserving and promoting the interest of Westerly's historic past. All those who have contributed to this important cause deserve thanks.

Across America, People are Discovering Something Wonderful. *Their Heritage.*

Arcadia Publishing is the leading local history publisher in the United States. With more than 3,000 titles in print and hundreds of new titles released every year, Arcadia has extensive specialized experience chronicling the history of communities and celebrating America's hidden stories, bringing to life the people, places, and events from the past. To discover the history of other communities across the nation, please visit:

www.arcadiapublishing.com

Customized search tools allow you to find regional history books about the town where you grew up, the cities where your friends and family live, the town where your parents met, or even that retirement spot you've been dreaming about.